# The Theater of Fernando Arrabal

The publication of this book
has been aided by a grant from the
Andrew W. Mellon Foundation

## THE GOTHAM LIBRARY
## OF THE NEW YORK UNIVERSITY PRESS

The Gotham Library is a series of original works and critical studies published in paperback primarily for student use. The Gotham hardcover edition is primarily for use by libraries and the general reader. Devoted to significant works and major authors and to literary topics of enduring importance, Gotham Library texts offer the best in literature and criticism.

Comparative and Foreign Language Literature:
   Robert J. Clements, Editor

Comparative and English Language Literature:
   James W. Tuttleton, Editor

# The Theater of Fernando Arrabal

A Garden of
Earthly Delights

*Thomas John Donahue*

New York University Press · New York *and* London

*To Theresa and Catharine*

**Library of Congress Cataloging in Publication Data**

Donahue, Thomas John, 1943-
    The theater of Fernando Arrabal.

    (The Gotham library of the New York University Press)
    Bibliography: p.
    1. Arrabal, Fernando—Criticism and interpretation.
I. Title.
PQ6601.R58Z64      842'.9'14     79-2598
ISBN 0-8147-1771-3
ISBN 0-8147-1772-1 pbk.

Manufactured in the United States of America

# Contents

# Introduction

Walking down the tracks away from the Gare St. Charles in Marseilles, the young, pale Spaniard's thoughts turn for a moment from his need to escape beyond the reach of railroad ticket takers to the Berliner Ensemble's production of *Mother Courage*. A long journey hitchhiking from Madrid, a few exciting hours in Paris, a full-blown production of Bertolt Brecht's play, a furtive eight hours on the train from Paris dodging *le contrôleur*—all have left him physically weak but even more enthusiastic about the theater—his theater. As Notre Dame de la Garde fades into the background, he pulls his light jacket around him to keep out the cutting blasts of the mistral. His mind is filled with the wonder of Paris, the extraordinary expertise of truly professional actors, the work of one of the most important playwrights of the century. His cough, the pain in his chest, his hunger are forgotten as he relives those moments in his mind, as he imagines his own world of dreams, illusions, and theatrical grandeur.

It is 1954. Fernando Arrabal has already written two plays in Spanish, *The Soldiers,* later called *Picnic on the Battlefield;* and *The Tricycle People,* later retitled *The Tricycle.* The later play won for him

1

second prize in the Barcelona playwriting contest the previous year. It would have given him first prize, but it was rumored quite falsely that he had plagiarized Samuel Beckett. Fernando Arrabal is unknown. He is a clerk, a dreamy type who reads a lot. Perhaps too much. He is a law student who likes the theater. Perhaps too much.

Born in Melilla, Spanish Morocco, in 1932, Arrabal's earliest years are shattered by the events of the Spanish Civil War; by the imprisonment of his father, an officer in the Republican army; and by his father's condemnation to death, later commuted to thirty years in prison. The Arrabal family leaves Melilla for Ciudad Rodrigo in 1936. The following year Fernando starts school. Already he has constructed a theater from cardboard boxes. The characters are figurines cut out of the newspaper. This same theater, into which he throws all his fantasies, undergoes several transformations, as he explains in his autobiographical novel, *Baal Babylone*:

> In the beginning, I used a lot of different characters. Later I used only a few so as not to knock them over when moving them around. In Villa Ramiro I made it out of cardboard. The inside was lighted by two hidden candles. In the beginning, I used a lot of painted scenery in each play. After, since I used only one—that was just an outline—you didn't have to wait for me to change scenes. Elisa didn't like to read the text, and so I did all the roles by disguising my voice. In the beginning, the characters were always running in and out. Later, since they hardly ever went in and out, you could follow what they were saying better. In Madrid, I replaced the two candles by two electric lamps. In the beginning, the characters did important things. Later, since they did the same things as us, you would talk much more about the plays. ... In the beginning, I divided each play into several acts. Later, since I made them into one act, you were no longer distracted. Each character was placed on a little wooden stick so that I could move them around. In the beginning, my theater was made of cardboard. Later in Madrid, since it was made out of wood, you liked it a lot more.[1]

Arrabal's love of the theater during his years as a schoolboy is sometimes challenged by his love of movies, of Charlie Chaplin, Buster Keaton, and Laurel and Hardy. One can imagine his teachers, the Escalopios Fathers, somewhat fearful of such secular influences on a young boy's mind. Later, at a prep school for the military academy, this starry-eyed youth is found lacking in military spirit. The memory of his father returns to him again and again. The discovery of a trunk containing letters from his father exacerbates his growing obsession with his father's fate at the hands of the Falangists. Knowledge of his mother's possible complicity in the affair marks him forever.

As he makes his way down the slope from the track bed to the road leading along the coast, he is more convinced than ever that he wants to be a playwright, that the law is not for him. The journey back to Madrid is not easy. The French are always wary of hitchhikers. Once on the other side of Montpellier, the towns pass more quickly—Béziers, Narbonne, Perpignan—he is almost back in Spain. Finally a Spaniard stops his car. The struggle with his halting French is over. A piece of bread and a slice of cheese calm his hunger.

Nevertheless, upon his return to Madrid he takes up his studies again. One cannot become a playwright in Spain very easily. His reading includes Fëdor Dostoevski, Franz Kafka, and Marcel Proust. He tries to find suitable literary friends. In the summer of 1954, he meets Luce Moreau, a French girl studying Spanish and Spanish literature in Madrid. They talk. She understands. His next play is *Fando and Lis*.

Intent upon returning to Paris, he applies for a government scholarship to study the theater. The Spanish House in the Cité Universitaire is to be his home. There he will have the opportunity to see plays, talk with playwrights, write, and experiment with his own theater. His cough persists. Paris for three months. This is his chance. Paris. A pain in his chest. Cough. He is admitted to the Hospital of the Cité Universitaire almost upon his arrival. The next year and a half is both painful and productive. He finishes *Fando and Lis* in the sanatorium at Bouffémont. *Ceremony for a Murdered Black*, *The Labyrinth*, and *The Two Executioners* follow. He is operated on for tuberculosis. The convalescence is long.

In the spring of 1957, Arrabal encounters Jean-Marie Serreau, the director, who is impressed by the young playwright's works. What takes place in the next year of his life brings him to the attention of a small but avid theatergoing public interested in the avant-garde theater. In October of the same year, the publishing house of Julliard gives him a lifetime contract and in 1958 begins to publish his works. In Madrid, in January 1958, the Dido Pequeño Teatro stages *Los Hombres del triciclo*. In March, *Picnic on the Battlefield* appears in print, and in November in *Les Lettres nouvelles* Geneviève Serreau's article on Arrabal's theater, appears—"Arrabal: a New Comic Style." Arrabal's career is launched, but he is in exile.

His exile, however, gives him a type of freedom he could not possibly find in Franco's Spain and gives his works much-needed exposure. A single performance of *Los Hombres del triciclo* in Madrid is all that is permitted his work. In France, Holland, Germany, and the United States, the experimental theaters of the time take notice of him and produce his works, although in a style so resembling that of Beckett's that the earlier charge of plagiarism seems to be given credence. Nevertheless, Arrabal's career is launched. He will become one of the most frequently produced playwrights in Paris in the 1960s, but also the playwright to incite critics to heights of indignation and venomous opprobrium. He will garner a reputation as an offbeat writer whose works are compilations of his own obsessions and have little application to the experience of the general public. But with éclat he will become one of the most important avant-garde authors of the 1960s.

In a sense, Arrabal's theater forms a part of the social revolution of the 1960s. It could not have received the notice it deserved without the freedom during that decade that permitted many experiments in the arts to take place. His theater deals most basically with freedom—the freedom to love; to live; to think; to express oneself; to permit light to be shed on the darker corners of the mind, on the hidden and sometimes hateful aspects of the human condition. This Dionysian characteristic of Arrabal's theater frequently finds expression in grotesque forms that repel the public because they reveal so much that most persons prefer to leave hidden. Yet it is this very characteristic that expresses Ar-

rabal's confidence in the fertility of the human mind and the irrepressible nature of the human spirit. It is no wonder that critics, despite their misgivings about much of his theater, continue to praise him for the good they find in it and encourage him to find forms that could be more easily appreciated by the general public.

I, too, have been both charmed and repelled by Arrabal's theater. I have been charmed by his innocent children and blithe adults, his trenchant humor and insight, but repelled by the unrelieved grotesquerie of some of his plays. This dichotomy in my own attitude toward his theater is among the reasons for my study of Arrabal. But the most compelling reason is the desire to bring to the American public a study of a theater that is important in its size, its concept, and its form. One cannot consider the avant-garde of the 1960s without Arrabal's theater. His plays enlarge and enrich the theater, break ground for others, point to new directions, and at the same time relate to tradition because, very simply, he speaks of human desires, thoughts, and actions.

I have studied from a thematic point of view what I believe to be the most characteristic elements of Arrabal's theater. Whenever possible, especially in the first chapter, I treat the works chronologically so as to give the reader a sense of the development and evolution of his canon. In addition, where I believe that it will help the reader to better understand his works, I relate his theater to the most important works of the avant-garde dramatists that precede him. Nevertheless, there are those who prefer to place his works within the cultural and literary traditions of the Iberian Peninsula. Although this latter view is true in part, it is my contention that Arrabal's theater, despite its origins, refers to a much larger and more international literary and theatrical tradition.

My reading and study of Arrabal's theater has made me more aware of the new and the different, yet no less critical of what I believe to be lapses in form and style. It has revealed to me the possibilities and the limitations of the contemporary theater, and above all the sincere attempts of one man to communicate his obsessions to the world.

In closing I wish to thank Professor Gerald Prince of the University of Pennsylvania, who urged me to undertake this study, and Mme Jean Vial of Dijon, who for years has kept me informed of

French critical reaction to Arrabal by clipping articles from both Parisian and provincial newspapers. To Professor David Burton, chairman of the Board on Faculty Research, and to the Administration of Saint Joseph's University, I express my sincere gratitude for the financial aid that allowed me to bring this project to a successful conclusion. To George Griffin, I owe the confidence that this study would one day be published. Most importantly, my family and friends I thank for years of encouragement and an endless fund of patience.

*Notes*

1. Fernando Arrabal, *Baal Babylone* (Paris: Union générale d'Editions, 1971), pp. 161-62. The translation is mine.

# 1.

# Arrabal's Children of Paradise

The avant-garde has always fascinated literary critics and the general public alike. On the one hand, it produces fear by presenting, sometimes violently, the unknown, the outlandish, a hint of what the future might hold; on the other hand, it inspires admiration by breaking away from the past and insisting on the new and the youthful. Despite his protests to the contrary, Arrabal is part of this long tradition. Today, literary critics remain fascinated by his works if not by his persona, and the general public, especially in France, fearfully acknowledges his rightful place in the pantheon of the theatrical avant-garde of the post-World War II period.

In his earliest plays, Arrabal, by giving a special role to the imaginative world of childhood, unwittingly stakes his claim to a place in the avant-garde. As Roger Shattuck perceptively points out in his study of the avant-garde of La Belle Epoque, the cult of childhood has been a hallmark of the various avant-garde movements starting with the romantics who rejected the classical man and his mature, balanced, and sober view of man and his world.[1] But aside from an emphasis on childhood, on the imagination, and on freedom from the constraints of the adult world, Arrabal creates

a special type of character in his plays that establishes the tone and weltanschauung for all the plays in the early years of his career. This character, whom we shall call the adult child, combines the imaginative, playful, sadistically cruel behavior of the child with the chronologically mature body of an adult. The adult child engages in long word games with companions, plays roles, murders his friends or is murdered, searches for a lost earthly paradise and for his own identity, and poses naive questions that put the human condition into a perspective that is at the same time cruelly absurd and comically insightful.

Arrabal's first professional venture into the theater, *Picnic on the Battlefield* (1952), is the naively wrought story of M. and Mme Tépan, who visit their son, Zapo, on the battlefield; encounter Zepo, an enemy soldier; and are killed by a hail of bullets from the two warring sides.

Zapo and Zepo are essentially interchangeable characters. They are of the same age; they are both engaged to be married; and they were drafted in the same way. The only thing that distinguishes them is the color of their uniforms. It is with them, however, that Arrabal begins to establish the moral naiveté that will become one of the principal characteristics of the adult child. Their moral systems, if one can call them such, tend to the mechanistic. They shoot their so-called enemy and then quickly recite the Hail Mary or the Our Father. In their eyes, asking for pardon is a sufficient safeguard against guilt. Of course, in this caricature Arrabal is ironically commenting on the good middle-class education of his two heroes by showing that they are doing their civic duty without forgetting the niceties of a more refined existence. Yet their lack of guilt demonstrates that reality never penetrates the fiber of their lives. Thus, Zapo can carry on his knitting, and Zepo can continue to make artificial flowers amid cadavers and flying bullets. War is not to be taken seriously; it is not much more than a child's game.

In *The Tricycle* (1953), Apal, Climando, Mita, and the Old Man also engage in the simplistic game of guilt and pardon, but in this play Arrabal expands his view somewhat and develops his characters more fully. Here the characters are not interchangeable but have personalities of their own. They do, however, share an interest in verbal play, and they do play the game of pardon. For instance,

in the second act, under Mita's prodding the Old Man asks Climando to beg his pardon for having insulted him. Climando does so, but mockingly.

*Climando.* And so you're going to take their snack from them. I can see that.
*Old Man.* You've still got it in for me, don't ya?
*Mita.* Yeh, Climando. You've still got it in for him. Beg pardon right now.
*Old Man (very content).* That's it. That's it. Let him beg pardon.
*Mita.* Go on, Climando, beg pardon.
*Climando.* Pardon . . . *(he adds very faintly),* but not for good.[2]

Begging pardon is extremely important in Arrabal's early plays; it rights the situation, creates a clean slate, and permits the characters to continue the game or activity until pardon is once again a necèssity. It means that no situation is final and permanent as long as a pardon can be asked and obtained.

It is just that sort of act that is put into relief in this play when the group decides to kill the man "with all the money" to pay for their tricycle. When the police arrive on the scene, Climando asks if he can beg pardon. He does not understand the finality of this act—or of any act, for that matter. In his mind, murder and insulting the Old Man are in the same moral category. This moral myopia is characteristic of Arrabal's adult children.

In *Fando and Lis* (1954), the game of pardon takes on some of the trappings of sadomasochism. In this play, Fando has chained Lis, his paralyzed partner, to a wagon while they search for Tar, an earthly paradise that always seems to be beyond their reach. As a prelude to Lis's murder, the two become involved in one of those typical children's arguments in which the original premise is lost but the argument continues with rising voices and shortened tempers.

*Fando (discouraged).* No, Lis, no. Not like that. Try again.
*Lis (who tries, but her words do not seem any more sincere than before).* I believe you.

*Fando (very sad).* No, no, Lis. How . . . how mean you are to me. Try
  again. Try again.
*Lis (who doesn't quite get it).* I believe you.
*Fando (violently).* No, no. That's not it.
*Lis (who tries desperately).* I believe you.
*Fando (even more violently).* Not like that, either.
*Lis (full of sincerity).* I believe you.
*Fando (emotionally).* Lis! You believe me?
*Lis (emotionally).* Yes, I believe you.
*Fando.* How happy that makes me! [3]

The verbal cruelty manifest in these dialogues on a very childish
level serves as a preparation both for the physical cruelty Fando
will inflict upon Lis and for her eventual murder. These "dialogues
of cruelty," as Ruby Cohn calls them,[4] form the underlying struc-
ture of the play and, at the same time, are the outward signs of the
master-slave relationship that exists between the characters. One of
its most prominent symptoms is the reversal of the two roles, so
that Fando will alternately be master then slave. Lis's character, of
course, will undergo the same reversals, which will result in a
whirligig of changing roles and postures. As Georg F.W. Hegel so
aptly pointed out, servitude is not only a historical phenomenon; it
is also a necessary stage in the development of the consciousness of
the self and the maintenance of that consciousness.[5] Given the
characters, Fando and Lis, who live on the outer fringes of society,
the master-slave relationship becomes a necessity if they are to
maintain the consciousness of their own selfhood.

As one would expect, this sadomasochism has an erotic aspect.
Fando likes to share Lis with others, just as Climando does with
Mita in *The Tricycle.* Fando, however, is much more open and
indiscreet. Not only does he show her thighs to the three men who
are also looking for Tar, but he also places her in the middle of the
road at night and invites whoever passes by to look at her thighs
and kiss her. This bizarre behavior does not stem from a lack of a
proprietary sense on Fando's part; it more likely is a consequence
of his own inability to possess her since he is impotent. Moreover,
she is much more intelligent than he, and thus an intellectual
relationship is out of the question. Fando compensates for his

inability by whipping her; by traveling so fast that she is made deathly sick; and eventually, in a fit of pique, by killing her.

It is this final act of murder that brings to an end the sadomasochistic aspect of the play and terminates the game of pardon, which during the play signals the various changes of posture of the two characters. Once the dialectic is established, pardon permits Fando and Lis to exchange roles continually, for it rights whatever wrong has been done. Only when Fando has murdered Lis is she locked in a stationary position. Only then is the act irreversible and not pardonable.

Nevertheless, one of the major reasons that the game of pardon can take place as readily as it does is that these sometimes winsome, sometimes cruel adult children have no real moral law upon which they can base their actions. They do, however, feel a need for some authority, and so they concoct systems of their own. Fando, is the author of a system whereby he is always able to tell who is right and who is wrong. But he makes no claim to objectivity and elaborates a system that is as relative as the truth he seeks is elusive.

*Namur (bored)*. Yes, sure *(pause)*. And what other ways have you used to tell who is right and who is wrong?

*Fando*. I used another way with the days of the week, but it is very complicated.

*Mitaro (interested)*. How does it go?

*Fando*. It's like this: on days that are multiples of three, men who wear glasses are right. On even-numbered days mothers are right, and on days that end in zero nobody is right.[6]

*Orison* (1957) puts into relief most poignantly the desire for some kind of moral order. Fidio and Lilbé, who have killed their infant child, attempt to establish a system by which they will know both right and wrong. The New Testament provides them with a touchstone since Christ, the good man par excellence, appeals to their childish endeavors. But their search is condemned to failure because the motivating factor is escape from boredom. They conclude that being morally upright can eventually be just as boring as being cruel and sinful. Geneviève Serreau, however, takes a

more sympathetic view of these poor tramps and their search for goodness: "Despite failure they persist, hardy and cheerful, cunning if need be, and dimly seeking, beyond the great models that darken the horizon, a way of living, a way of being, that will at last be the right one, that will establish a possible goodness among men." [7]

*Automobile Graveyard* (1957), Arrabal's first full-length production, combines most of the elements that he developed in his shorter plays and playlets: the game of pardon, the master-slave relationship, sadomasochism, moral ambiguity, and the erotic. The characters are all adult children like those observed in his earlier endeavors. He adds to this formula a new structuring element, the game.

The play is a naive and simplistic representation of Christ's Passion and death. Emanou (for Emmanuel), the protagonist, is pursued by the police for playing his trumpet for the poor people. The fact that he is a murderer does not seem to interest them. In his pursuit of goodness, Emanou is joined by his two fellow musicians, Fodère, a mute; and Topé, who, Judaslike, will betray him with a kiss. Before the end of the play, Lasca and Tiossido, two athletes turned policemen, will whip him, stretch out his body on a bicycle, and hang him from a pole.

The setting for the play is an old automobile graveyard that serves as a hotel for a group of sexually rapacious beings who are waited upon by the aristocratic Milos, the valet, and Dila, a chambermaid. The derelicts amuse themselves by ordering Milos to fetch them spirits and the chamber pot or by watching Dila and Emanou attempt to make love behind one of the decrepit autos. They are all adult children, innocent murderers, voyeurs, and exhibitionists. They like to urinate and make love. They hate the police but are constantly pursued by them. They inhabit a no-man's-land on the edge of the "real" adult world.

Around the trio of Emanou, Fodère, and Topé are two sets of couples: Milos and Dila, the caretakers of the automobile hotel; and Lasca and Tiossido, the athlete and trainer who arrest Emanou after their abrupt transformation into policemen. Both couples are involved in a master-slave relationship. Their roles, as

is normal in such a relationship, are subject to reversal, since as Hegel has pointed out, the master and slave are caught in a dialectical situation in which the master becomes dependent on the slave because the slave provides the master with most of the necessities of life.[8] The master thus passes from a state of independence to a state of dependence on his slave.

When we first meet Dila, she goes about the graveyard like a great mother obliging all the inhabitants to bed down for the night. Then she gives herself to any male who desires her. Milos watches over her with a satisfied air as she goes from one car to another. When he finds Emanou trying to make love to her behind one of the cars, he awakens everyone in the camp so that they can watch as well. Naturally when Dila reprimands him for his improper behavior, he acts like a child. Then Dila demands that he beg pardon before all the inhabitants of the graveyard who look on laughing from behind their burlap-screened windows.

*Dila.* But first you must beg pardon.
*Milos.* Yes, Dila, pardon me.
*Dila.* On your knees, and say it better than that.
*Milos (on his knees).* Pardon me, Dila *(giggling from inside the cars).*
*Dila.* You can go to bed now.[9]

This familiar scene is repeated on several occasions as the two exchange roles.

The relationship between Lasca and Tiossido is much more rigid, but it follows the same pattern. In the first act, Lasca, an older woman with gray hair, urges Tiossido to break a track record. Lasca enters counting, reminding the young man of his breathing and posture. Each time they enter, Tiossido is more and more fatigued, until finally he falls to the ground exhausted. To rest from their day's activities and to enjoy a night of illicit sex, the two take a "room" in the automobile hotel run by Milos. The next morning (the second act) both are dressed as policemen, and Tiossido is in complete command.

This type of master-slave relationship is quite common in Arrabal's universe, and he uses it in some form throughout his canon.

But it is with his adult children that he develops most of its variations. It invariably manifests itself in the sadomascochistic games of the characters who exchange roles of executioner and victim in a savagely moving chess game. When the executioner consummates the act and oversteps his bounds, the game is ended, as we saw in *Fando and Lis*. In this play, however, the game continues in a gentler manner.

In the midst of these two couples is Emanou, who like Fidio and Lilbé before him, wants to be good. He plays his trumpet for the poor people of the quarter so that they can keep warm on winter nights; he knits them pullovers and gathers daisies so they can play love me, love me not. Yet, at the same time, he is a murderer who kills people when they are bored.

His desire to be good is not based on a rational argument that he has thought out for himself in a reasonable manner. Several times during the play he repeats in parrotlike fashion the basis for his quest for goodness: "Well, when you're good, you feel a great interior joy born of the peace of mind that you enjoy when you see yourself in the image of man." [10] Moreover, in the second act, he has difficulty recalling this senseless principle of his. Dila cynically reminds him that being good in such a world only causes trouble: "Just think what would happen if everyone got it into his head to be good like you." [11] And she is right, for like Luis Buñuel's *Nazarin*, Emanou's every good action results only in an opposite reaction. For example, when he is a few minutes late for his nightly concert, he is threatened with lynching; and when he feeds some people in the crowd a few sardines and some bread, the others become jealous. Eventually, his "subversive" activities lead to his pursuit by the police and his betrayal by one of his friends.

Through Emanou, Arrabal draws without ambiguity a parallel with Christ and Christian mythology and, it seems, debunks the basic Christian ethic of charity and love. Emanou's portrait as a Christ figure is unmistakable, as his description of his birth makes clear:

*Emanou.* My mother was poor. She told me she was so poor that when the time came for me to be born, nobody would let her come into their house. Only a little cow and a donkey that

were in a broken down stable had pity on her. So my mother
went into the stable, and I was born. The donkey and the cow
warmed me with their breath. The cow was happy to see me
born and went "Moo!! Moo!!" and the donkey brayed and
wiggled his ears.[12]

In the second act, the parallels with Christ's Passion and death are
just as naively drawn. Topé betrays him for a certain sum of
money and identifies him by kissing him on the cheek. Fodère, his
mute friend, betrays him three times as Saint Peter did Christ.
And Dila wipes his face with a cloth a la Saint Veronica. The
portrait is so clear as to be blasphemous to some. Emanou is after
all a murderer who likes to sleep with women. But what is more
important is that his good actions have little effect on his commu-
nity and, we are to assume, no lasting effect whatsoever. Arrabal
seems to demonstrate that the Christian myth is not workable in
this new context, if it ever was.

It is in the moral sphere that the Christian world view becomes
particularly hazy. As he did in *Orison,* Arrabal equates good and
bad. Being good brings no evident recompense, so one might just
as well be bad. Such a state of affairs has its ironic aspects, as we
see in the scene in which Emanou explains to Topé how one can
commit murder and get away with it.

*Topé.* So nobody can kill someone without getting caught?
*Emanou.* Sure you can. But you have to be well organized. There is
    a way, but you have to go to school for a long time.
*Topé.* How's that?
*Emanou.* You can be a judge.
*Topé.* Do they make a lot of money like murderers?
*Emanou.* Yeah, a lot.
*Topé.* And who do they kill, these judges?
*Emanou.* They kill the people who do bad things.
*Topé.* How do they know they are bad?
*Emanou.* You have to be really sly.[13]

The gradual lessening of the distinction between bad and good
and the increase in the ambiguity of the moral climate in this play

is marked by seven entrances of Lasca and Tiossido. At each successive entrance from the right-hand side of the stage, Tiossido is more and more tired until he finally loses his way and enters from the left-hand side. When he collapses, his physical exhaustion represents a moral exhaustion as well, for he persuades Lasca to spend the night with him at the automobile hotel. The entrances of these two characters not only give a structure to the first act but reflect the theme of the moral collapse of the world around them.

In the second act, the parody of the Passion and death of Christ forms the unifying element. Within this framework, a chase scene of comical proportions leads to the eventual betrayal and capture of Emanou. When Topé agrees to betray his friend to the authorities, Lasca and Tiossido take off as if racing, followed by Topé. They are actually in search of Emanou, but the race itself becomes the center of attraction. Binoculars appear from the burlap-covered windows as the characters become spectators. Emanou and Fodère run about in the hunched positions made famous by the Marx brothers until they realize that Lasca and Tiossido are much more interested in Topé's inability to keep up with them. Meanwhile, a rising murmur of voices repeating bits and pieces of clichés and the sounds of clanging metal build to a crescendo. When everything abruptly comes to a halt, cries of a newborn baby emanate from one of the old automobiles. Emanou's capture and death follow.

The chase scene with its excitement focuses our attention on several aspects of the metaphor presented in this play. The fact that the participants return at regular intervals and that they are actually running in circles expresses in one more way the closed and suffocating nature of the world these characters inhabit. Moreover, it shows that there is no hope for an exit from the graveyard except through death. When the chase is over and Emanou is finally captured, the group of child sadists systematically kill a newborn infant. This final act of brutality reinforces the theme that there is no hope in a world gone out of control. We can be sure that Emanou will not be resurrected in three days.

With this play Arrabal has created a rich and imaginative metaphor for the decay of our technological civilization and the col-

lapse of all systems of morality. He has given us an impotent Christ figure who is more akin to a Chaplinesque tramp than to a savior and a cast of characters who tenderly murder and brutally love. Because the symbol of the automobile graveyard is so rich in meaning, the thoughts and views of Arrabal's children become all the more penetrating and relevant, their questioning of any moral standard all the more poignant.

In *The Grand Ceremonial* (1963), Arrabal takes the basic themes of innocence, pardon, and sadomasochism cum eroticism and pushes them into the realm of the pathologically perverse. Cavanosa, the lame protagonist of this play, encounters young girls in a park near his mother's apartment, woos them, takes them to his room, dresses them like Christ, and eventually kills them. He seduces them by calling them whores and recounting his sexual fantasies; he chats about the size of his penis and his obvious deformities.

Cavanosa, as his name not so subtly indicates, is a lover, but he is very unlike his famous predecessor. He is ugly, crippled, and hunchbacked. His love for women is perverted and intensely based on torture. Even his love for his mother breaks the ancient oedipal taboo. Yet he acts and speaks very much like the other heroes that people Arrabal's universe. He is a child-adult sadist; he lives in his own fantasy world and speaks a strange, poetic, surrealist language. Although his cruelty is overwhelming, he shares that honesty of the other childlike characters of Arrabal that permits him to talk of his fantasies and obsessions in an almost clinical fashion. Moreover, he views "the human situation with the uncomprehending eyes of child-like simplicity" and fails "to understand or even notice, the existence of a moral law," as Martin Esslin so succinctly described the major characters of these early plays.[14]

Not recognizing a moral standard, living in a world of his own obsessions, Cavanosa encounters with every entrance into the other world of the park a way of being and acting that is the very contradiction of his own. His mother, who is understanding in most things concerning him, points out Cavanosa's extraordinary inability to adapt because of his basically different nature. She says that he is very much like his father, whom she describes as a person who played the game of life honestly without any trickery, who

tried to go beyond the truth and did not hesitate to present himself in the most unfavorable way, and who vaunted the most terrible vices.[15] Cavanosa, it seems, takes after his father.

All of Cavanosa's reactions are the opposite of what one would expect: love brings forth only his scorn; any affection shown him incites him to anger; any kindness offered him produces a cruel reaction. This is his manner of being in the world, and as he says to Sil, he cannot change: "You must stop trying to make me leave my world. I cannot leave it." [16] The result is a character, not only different from the others, but one who realizes he is different and is able to observe himself functioning with ironic distance. Because Cavanosa is aware of his own bizarre nature, he can play the role of this strange character and augment those characteristics that distinguish him from "normal" people. This role playing lends a theatrical element to the way he exists in the world and to the way he wants to be seen. Arrabal, when asked about the theatrical quality of some of his characters, chose to speak specifically about Cavanosa, of whom he says:

> Look at the character of Cavanosa in *The Grand Ceremonial,* for example. He expresses himself like everybody else and then abruptly he speaks in an abnormal way. But the "abnormal" way emphasizes the normal way people speak, that is, normal beings who are neither "different" nor obsessed. Cavanosa is a Dostoevskian character. In other words, he plays the game of normal people but he never puts on their mask; he keeps his distance ironically and painfully.[17]

Into the antipodal and theatrical universe Cavanosa inhabits come Sil and Lys. As their names indicate, they are reverse images of each other. And so their efforts to penetrate Cavanosa's world meet with opposite results. No matter how Sil tries, her every effort to be pleasing is met with scorn. When she brings him flowers, Cavanosa stamps on them and tells her that a box of manure would have been better, but best of all, a whip so that he could beat her. Having tried everything, however, she finally gives herself to him as a slave. But he refuses her because she has not participated properly in his ceremony. Instead, he gives her to his mother,

who beats her. She willingly obliges in all this in order to remain near him. Lys, on the other hand, does intrude upon Cavanosa's world, remains there to seduce him, and tears him away from his mother. From the first, Cavanosa treats her differently. Although he pushes her to the ground and makes her cry, he does not call her a "little whore" as he did Sil. Lys is different. Unlike Sil, who had to be told what was necessary to please Cavanosa, Lys instinctively knows. She brings a whip, which she most likely made herself, so that Cavanosa can beat her for being "nice" to him. She willingly allows him to caress her knees and slowly begins to become a part of his life:

*Lys.* Have you pardoned me?
*Cavanosa.* That's good.
*Lys.* We'll be friends?
*Cavanosa.* A little.
*Lys.* A little . . . but, forever?
*Cavanosa.* Yes.[18]

Finally, she gets into the wagon Cavanosa has with him, removes the doll Cavanosa always carries with him, and cajoles him into giving her a ride around the park. Then she leaves with him on his long-planned trip to the "Orient" (where he will not be considered a monster), despite his warnings that he will kill her "par amour," just as he has destroyed many of his dolls and her predecessors.

Lys is the woman-child prostitute who is so familiar to the early plays of Arrabal. She is innocent—for she does not know what guilt is—and she is lily pure, as her name indicates. Yet at the same time she is willing to kill Cavanosa's mother "if it is easy." She is also very beautiful and, in this one way, very different from Cavanosa. Otherwise, their worlds coincide. She was tied to her mother physically just as Cavanosa is tied to his mother emotionally; she makes whips, and he uses them; she paints dolls, and Cavanosa "loves" them.

Cavanosa's mother is authoritarian, sadistically cruel, and classically vindictive. The power she exercises over her son is slowly failing, and she knows that she will be soon replaced by one of the girls Cavanosa meets in the park during his daily ritual. What is

more, she knows that her son wants to kill her. However, in this game she is a past master. She knows the rules and plays well. When he threatens her with a knife, she cries out, "That's what I was afraid of. With this knife five hours of agony." [19] She knows that her son does not have the strength to kill her, and consequently she ever so tenuously maintains control over him. Of course, like most of these characters, she plays the game of pardon. When she goes to give him a good-bye kiss, she stabs her nails into his back and forces him to beg pardon:

*Mother.* Now I'm in command here. Try and rebel now.
*Cavanosa.* Mama!
*Mother.* That's it. Humble yourself. Humble yourself and beg pardon.
*Cavanosa.* Pardon me.
*Mother.* Say it better than that. Say: "Pardon me, dear, sweet Mother." [20]

Thus, for one last time, she extorts from him a demand for pardon. We see here once again a master-slave relationship in very sadomasochistic terms in which the executioner becomes victim and once again executioner.

Into this world of cruelty and perverted love Arrabal introduces a new element, Sil's lover. The role he plays is very much like that of a spectator. He is from the outside world; he rejects this strange world he has stumbled into but is forced to participate in it. His first reaction is, "I'm suffocating in your world, I'm suffocating." [21] Later, when he deigns to play a little game, Cavanosa quickly puts him into a judo hold and handcuffs him. Like many a spectator at a very violent, incomprehensible avant-garde play, he shouts, "How did I get myself into this madhouse!" [22]

With the lover, Arrabal has ingeniously allowed us to observe ourselves and our reactions during these violent theater games. Moreover, he permits us to reject one of his basic themes in the play: that love is violent and involves the emotional and psychological imprisonment of another person.

The basic relationship in these plays, as we have seen, revolves around the child-man-sadist, the child-woman-prostitute, and the

child-mother-sadist, all of whom engage in a sadomasochistic game tinged with eroticism. Françoise Raymond-Mundschau, in her critical study of Arrabal and his theater, rightly believes that this relationship establishes the basic structure for most of Arrabal's plays in which the child adult plays the principal roles. She draws an incisive analogy between these characters and pawns in a chess game that have no value except in relationship to all the other pieces.[23] Like pawns, these children have no reality except in relation to each other.

This basic relationship, pushed into the realm of the pathological in *The Grand Ceremonial*, sheds some light on the psychological aspects of all these characters and helps us draw some conclusions about them. It also puts into proper perspective the sadomasochistic games they revel in. The common denominator that relates all of these characters is the anxiety that obliges them to act in some socially unacceptable fashion.[24] Cavanosa is an obvious example. His relationship with his mother, which explodes in the terrible game of pardon, only masks the underlying anxiety he feels in her presence. She is not only an authoritarian tyrant; she personifies all his fears of impotency and, at the same time, his overwhelming desire to copulate with her. His fear of impotency is in part allayed by his masturbatory activities with his life-sized dolls, and his oedipal anxieties are in part allayed by the daily wooing and murder of a girl he meets in the park. Cavanosa, however, is not able to distinguish between his fantasies and reality. In effect, his fantasies are his reality. What we see in this play is a daily acting out of his fantasies and his fears until he meets Lys, who is able to participate in his fantasy world turned reality. Lys, of course, is merely a replacement for his mother and his dolls. She allows him once and for all to externalize the relationship that he has imposed upon his mother and that she in turn has imposed upon him. From the Freudian point of view, *Fando and Lis* is a continuation of *The Grand Ceremonial*, since Lis of that play has replaced Fando's mother in his world and allows him to externalize his hidden fears and guilt.

Given the authoritarian female figure that constantly reappears in these plays, it is not surprising that the chamber pot is a recurring image. Since authoritarian mothers put great emphasis

on proper toilet training and instill in their children the fear of making a mess, the chamber pot symbolizes the child adult's desire to please the mother, to obtain her trust, and to avoid guilt and shame. The chamber pot, which is so often given as a gift—a *don*—in these plays, becomes a part of the game of par-*don*, which in its original sense means giving over and above.

The only other authority in Arrabal's amoral world is the police. Yet they always remain external to the play except in *The Tricycle*, where they actually appear onstage, speaking an incomprehensible language. Even in *Automobile Graveyard*, Lasca and Tiossido, who dress as policemen in the second act, appear to remain more athletes than policemen as they pursue the hapless Emanou. In *Ceremony for a Murdered Black*, they pound on the door of Jerome's and Vincent's atelier, but they do not enter. It is significant that they do not represent a moral authority in these plays, only a brutal and mysterious political authority. They are, however, one more outward manifestation of the child adult's internal anxiety and fear.

The brooding, enigmatic, and mysterious character of Arrabal's universe is put into relief in *The Condemned Man's Bicycle* (1959) more than in any other play. In this play, Paso is at once victim and executioner. He is the battered and bleeding mass that Tasla pulls about the cage attached to the bicycle. Later he is the red-headed fellow who mocks Viloro for not properly executing the C scale on the piano. Still later he is the murderer who takes Viloro's life. He is imprisoned yet free; beaten and bloody yet well. In effect, we do not know if it is Viloro or Paso who is the condemned man of the title. The unanswered question concerning the identity of the condemned man complements Arrabal's interrogation on the nature of liberty and condemnation that is the basic theme of this play.[25] The fact that freedom for some men can be condemnation for others is the enigma that Arrabal attempts to discuss in theatrical terms.

The one area of freedom that is truly left open to these pitiful creatures is language. Whether they are condemned to search for an unattainable paradise like Fando and Lis, or to escape their own deformities like Cavanosa, or to live in an automobile grave-yard, the one real freedom that remains to them is their ability to

use language either to express themselves poetically or to protect themselves from the harshness of reality. These lyrical passages are the only evidence of beauty in an otherwise ugly world. Viloro sings one of these songs for Tasla in *The Condemned Man's Bicycle:* "Will you think of me? Will you remember me behind your azure-blue beach eyes? Will you remember me folded into your instant and suspended from your burst of colors? Will you write other poems for me? Will you give me alphabets and mansions that inflame and illumine me?" [26] All of Arrabal's principal adult children use these surrealistic prose poems in order to escape from the world of rationality and the mental prison of everyday speech. Arrabal thus creates a new world of imagination for these creatures who will be crushed by society.

Moreover, Arrabal adds another element to his adult-child analogy; he depicts an important aspect of children's behavior. Children will often retreat into their own fantasies and will not attempt to communicate with whomever they are addressing. Jean Piaget, in his study of children's language and thought processes, describes some of the symptoms of what he calls egocentric speech:

> He does not bother to know to whom he is speaking nor whether he is being listened to. He talks either for himself or for the pleasure of associating anyone who happens to be there with the activity of the moment. This talk is egocentric, partly because the child talks only about himself, but chiefly because he does not attempt to place himself at the point of view of his hearer. Anyone who happens to be there will serve as an audience. [27]

To reinforce the childhood analogy Arrabal also uses other accouterments of the child's world. Wagons, tricycles, dolls, and balloons all make their appearance in these plays, along with the ever present chamber pot that emphasizes the child's fascination with urination and defecation. These outward signs of a child's world are poignantly juxtaposed with the instruments of torture: whips, chains, handcuffs, and cages. Thus, in a theatrical way Arrabal brings together the innocence of children and their fantasies and the brutal, sadomasochistic games he forces them to

play. He thereby indicates on one level the fact that children, despite their innocence, can be mean and brutal and that adults, despite their so-called maturity, are not much different but can certainly be much worse.

Despite my belief that Arrabal's child-adult character is unique in the contemporary theater, comparisons can be drawn with characters of other playwrights. Beckett's tramps in *Waiting for Godot* inhabit a no-man's-land similar to Arrabal's, and they are searching for something they do not have the capability of attaining. They are occasionally involved in a master-slave relationship and are sometimes afraid of their own freedom. Moreover, many of Arrabal's plays have a circular structure similar to that of Beckett's plays, which reflects the inability of his characters to escape from their world. Mme and M. Tépan of *Picnic on the Battlefield* possess all the zaniness of the Smiths in Eugène Ionesco's *Bald Soprano;* Fanchou and Lira, the old couple buried beneath the rubble of their own house in *Guernica,* have a remarkable resemblance to the old couple in *The Chairs.* The early plays of Arthur Adamov, such as *All Against All,* foreshadow the nightmarish surrealism of a play like *The Condemned Man's Bicycle.* It is not surprising, then, that Martin Esslin should place Arrabal among the absurdist playwrights.

Nevertheless, the originality of Arrabal's child-adult metaphor cannot be overlooked. The image of these bereft creatures living on the edge of the "real" world, trying to become someone, speaking their naive but poetic language, loving in the only way they know how, and dying as a result of their own murderous ennui is a perceptive if depressing metaphor for our own world.

That is not to say that there is no joy in this universe. These characters have not given up hope, and they can, like children, still have fun. From the point of view of the spectator, however, the distance that is established between what these hapless children want to be and what they really are, between what they strive to do and what they do, gives a comic luster to these plays reminiscent of the type of comedy produced by the pratfalls of Chaplin's tramp. In effect, the childish laughter of Emanou, Viloro, Zapo and Zepo, and Fando and Lis is their weapon against the crushing social forces they encounter. At the same time, it is our only

defense against the overwhelming odds and the senseless injustice we perceive in these plays.

It is certainly a sign of Arrabal's maturity as a playwright that he was able to abandon these sometimes charming, sometimes cruel children as the basic element of the universe he had created. He realized, first of all, that it was difficult to find actors or directors who understood the type of character he was trying to create. The simplicity and childlike nature was, according to Arrabal, mistaken for childishness. Instead of the perceptive simplicity of children that Arrabal hoped for, actors generally portrayed naughty, talkative imps. Jacques Guicharnaud describes this pitfall in a study of Arrabal's children: "Children often delight by the alternation of their innocent remarks and their perversity, but they can manage to wear us out by talking too much, and when—along with us—they are in danger of death, we rather feel like doing something else." [28] Yet, despite the problem these characters pose for both actor and spectator, when Arrabal succeeds in creating the proper tension between the child and the adult, as he often does, their words become frightening weapons in their arsenal.

The nightmarish world Arrabal has created with the help of the adult children is a direct product of his own imagination, his subconscious, and his surrealist dreams. It puts into perspective our real world, its ambiguous morality, its social and political injustices, and perhaps most important, the way we live, love, and die. But happily for us, the sadness that is inherent in Arrabal's world view is successfully countered by the constant apparition of the marvelous and the extraordinary. It is this poetry that permits his children to live in their paradise.

## Notes

1. Roger Shattuck, *The Banquet Years* (New York: Vintage Books, 1955), p. 31.
2. Fernando Arrabal, *Théâtre 2* (Paris: Christian Bourgois, 1968), p. 147. All translations are mine unless otherwise noted.
3. Fernando Arrabal, *Théâtre 1* (Paris: Christian Bourgois, 1968), p. 65.
4. Ruby Cohn, *Currents in Contemporary Drama* (Bloomington: Indiana University Press, 1969), p. 229.

5. Georg F.W. Hegel, *The Phenomenology of Mind,* trans. J. B. Baillie (New York: Harper and Row, 1967), p. 229.
6. Arrabal, *Théâtre 1,* p. 97.
7. Geneviève Serreau, "A New Comic Style," *Evergreen Review* (November-December 1960): 66.
8. Hegel, p. 237.
9. Arrabal, *Théâtre 1,* p. 56.
10. Ibid., p. 162.
11. Ibid., p. 200.
12. Ibid., pp. 154-55.
13. Ibid., p. 139.
14. Martin Esslin, *The Theatre of the Absurd* (New York: Anchor Books, 1961), p. 186.
15. Fernando Arrabal, *Théâtre 3* (Paris: Christian Bourgois, 1969), p. 72.
16. Ibid., p. 51.
17. Alain Schifres, *Entretiens avec Arrabal* (Paris: Pierre Belfond, 1969), p. 125.
18. Arrabal, *Théâtre 3,* p. 138.
19. Ibid., p. 74.
20. Ibid., p. 77.
21. Ibid., p. 107.
22. Ibid., p. 117.
23. Françoise Raymond-Munschau, *Arrabal* (Paris: Editions universitaires, 1972), p. 103.
23. Ibid., pp. 93-95.
25. Beverly J. De Long-Tonelli, "Arrabal's Dramatic Structure," *Modern Drama* 14 (September 1971): 207.
26. Arrabal, *Théâtre 2,* p. 214.
27. Jean Piaget, *Language and Thought of the Child,* trans. Marjorie Warden (New York: Meridian Press, 1955), p. 32.
28. Jacques Guicharnaud, "Forbidden Games, Arrabal," *Yale French Studies* 29 (1962): 119.

# 2.

# Panic Theater: The Baroque Dream

The early years of Arrabal's career were certainly not easy ones. His arrival in France, the discovery of his tubercular condition, his inability to get published or produced, and then failure when finally produced all took their toll on his self-confidence. Yet, like one of his creations, the adult child, Arrabal never took to despair. Instead he put his creative energies to work on a novel, *Baal Babylone,* which he started toward the end of 1958, and he even tried his hand at some acting.[1] In 1958, *Les Lettres nouvelles* published *Picnic on the Battlefield,* and soon after, Julliard, the publishing house, offered him a lifetime contract and published his first volume of plays, which contained *Orison, The Two Executioners, Fando and Lis,* and *Automobile Graveyard.* During this period Arrabal also saw *Picnic on the Battlefield,* his first play, directed by Jean-Marie Serreau, who had just directed an important production of Jean Genet's *The Blacks.* Also in 1959, Geneviève Serreau published an important article devoted to his theater, "Arrabal: A New Comic Style." [2] Over a period of several years, approximately 1958-1960, Arrabal became more fully aware of his role as a playwright, and the critics became aware of his presence. His self-

consciousness as a playwright, and his overwhelming creative energies led him at first to another medium, that of the novel, but his interest in the theater never flagged.

In late 1959 Arrabal received a grant from the Ford Foundation to study and observe the theater in the United States. He left for the United States in the company of Ugo Klauss, Italo Calvino, Claude Ollier, and Robert Pinget. His six-month stay in America included trips to Las Vegas and Miami, with excursions to Canada and Cuba. He found American theater to be disappointing. "The theater? It was very bad. It was everything I really dislike. The Living Theatre was putting on Molière. Besides, it was just then that Peter Brook was producing *Irma la Douce.*" [3]

Upon his return to France the following spring, he started writing another novel, *The Burial of a Sardine.* In the fall a disastrous production of *Theatrical Orchestration,* later entitled *God Tempted by Mathematics,* prompted the self-criticism that what had seemed like a comical abstract theatrical piece was only boring. The next year saw the publication of *The Burial of a Sardine* and the second volume of plays. More important, however, was a production of *Fando and Lis* by the young Mexican director, Alexandro Jodorowsky, who shares some of Arrabal's visions.

In 1962 Arrabal started frequenting the surrealist group that gathered weekly around André Breton. Although he remained on the outer perimeter of the group, he no doubt listened and perhaps even took part in some of the theoretical discussions surrealists are prone to. Significantly, the first of Arrabal's "panic" texts was published in *La Brèche,* [4] Breton's surrealist review. His association with the surrealists was, nevertheless, ephemeral.

The more important encounter for Arrabal and his development as an artist took place at the Café de la Paix where Arrabal, along with Jodorowsky, Roland Topor, and Jacques Sternberg, founded what they were to call the panic movement.

If one were to ask any of these men today what "panic" is or was, they might be hard put to give an answer, and more likely they would disown "panic" as an aberration of their youth. But it was to have a profound effect upon their work, and it gave birth to a series of theatrical events that kept Parisian devotees of street

theater, happenings, and the avant-garde both bemused and amused.

In Sidney, Australia, where he went for a production of *Fando and Lis* in August, 1963, Arrabal gave a lecture on his panic theory.[5] This lecture, the fruits of his musing on the subject, took the form of an antimanifesto in which a mathematical joke and more serious thoughts concerning memory, chance, and the role of the artist are intertwined in a manner both humorous and confounding. Named after the great Pan, god of merriment, terror, and surprise, panic, like many literary categories, is a difficult concept to define precisely. At first, Arrabal and his friends devised the term in order to confuse án all too susceptible public and tweak the nose of academics whom they thought would be prepared to write tomes on the subject. Despite their efforts to be purposely obscure, some readily identifiable characteristics crept into their discussions of panic and became part of Arrabal's theater.

One of the prinicpal characteristics of panic is its all-encompassing nature. For Arrabal, Panic Theater includes tragedy and *guignol,* poetry and vulgarity, comedy and melodrama, love and eroticism, the happening and ensemble theory, bad taste and aesthetic refinement, the sacrilegious and the sacred, murder and the exaltation of life, the sordid and the sublime. With Artaudian fervor, he says: "I dream of a theater in which humor and poetry, panic and love are united. The theatrical rite would then be transformed into an 'opera mundi.' It would be just like the fantasies of Don Quixote, the nightmare of Alice, the delirium of K., indeed the humanoid dreams that haunt the nights of an IBM machine." [6]

Being everything, panic would seem to be nothing. This is not the case, for Arrabal assigns to the artist, the panic man, roles that help to define the term. The artist, he said, creates the unforeseen, the unexpected, by using the faculty of memory, which in turn controls the artist's sensibilities, his intelligence, and his imagination. The artist is dependent on chance, which some might define as originality, others as genius.

In his speech in Sydney, Arrabal began by explaining his interest in the faculty of memory. He said that after reading one of his

own texts that seemed to him to have been "dictated," he saw the importance of memory, which beforehand he had considered only secondary. His interest was kindled when by chance he came across a text on mythology that contained a diagram in which Kronos (time) and Mnemosyne (memory) were related. What intrigued him was the fact that Mnemosyne is, according to the text, the only human faculty to figure among the Titans. Moreover, he learned that the union of Zeus and Mnemosyne engendered the nine muses.[7]

Inspired by these discoveries, Arrabal began to read all the major thinkers and writers who studied the faculty of memory: Henri Bergson, Georges Gusdorf, Henri Ellenberger, Maurice Merleau-Ponty, even Aristotle. He was somewhat surprised to find that these great minds remained puzzled by the mystery of memory, and, according to him, that they could muster only a superficial or incomplete definition of it. Even his search in all of the major dictionaries for a succinct definition left him disappointed.

Having arrived at an impasse in the more traditional manner of research, Arrabal began to pursue his thoughts on memory in a nontraditional if not antitraditional manner. He explains that during a period of several years he practiced what the surrealists call *le cadavre exquis.* By this process, Arrabal would choose a word or sentence from a book completely by chance. Later, he would choose another word or phrase so that the first and second choice would form a complete sentence from a purely grammatical point of view. One day he composed the following sentence in this manner: "The future is acted out in 'coups de théâtre.' "

Arrabal was fascinated by this find, since he had thought for some time that the future was totally permeated by chance and that confusion governed the past, the present, and the future. At this point in the development of his theory, he posited memory, chance, and confusion as the three primoridal problems. It is this last element that he felt defined the human condition. For him, perfection, beauty, purity, and morality tend to create an artificial situation of nonconfusion—a particularly inhuman characteristic. Confusion thus found its way into his theory and into his theater.

At this point in his talk, Arrabal introduced a mathematical joke and a few free associations that permitted him to conclude that life

is memory and man is chance. He reached these conclusions by first positing the following: that memory is totally dependent on chance and that the past at one time was future.[8] To represent these thoughts he drew up the following equations:

$$\text{Memory} = \text{chance}^2$$
$$\text{Memory} = \text{ex-chance}$$
that is to say:
$$\text{Memory} = \text{chance}$$
$$-1 = \text{chance}$$

Then through a series of associations that border on spoonerisms, he concluded: "And from that mathematical joke came the echo of a text of [Beckett]: 'I am the square root of minus one.' And recalling the cliché 'the style is the man,' I arrived at 'chance is man' or more precisely that 'man is chance.' "[9]

Despite the mock-serious tone of Arrabal's attitude, his thoughts on the role of the artist are particularly perceptive and merit our attention. Concerning chance and the artist, he said:

> In order to instill chance into his work, the artist is the only man on earth who tries to show what is unpredictable, the future, tomorrow. The artist has always created with the two vital and fundamental problems at hand: bring together the mechanisms of memory and the rules of chance.
>
> The more the work of an artist is filled with chance, confusion, the unexpected, the richer, the more exciting, the more fascinating it will be.[10]

Great artists have always provided us with insights on the human condition by transcending the normal limits of reality. But Arrabal is demanding more than that, it seems to me. He perceives the artist's work as depicting what man is as well as what he might be, of what man was and what he is becoming. Man is chance, for he has always been the variable factor in life. Man's essential individuality assures a kaleidoscope of feelings, emotions, actions, and creations—a never ending panic feast.

Arrabal's emphasis on memory is important because it is by

means of the memory that the artist gives form to his creations, gives life to his metaphors, and grasps the meaning of life. On a purely superficial level, this theory might mean that the artist relies on autobiographical data in order to create. However, memory can also be the mechanism by which the artist attains universality. The memory gives him a perspective on the experience of the human race; it not only recalls what happened historically to his ancestors, but it permits him to delve into the human consciousness where he can touch the deep-seated feelings of fear, hate, love, and despair that are common to all human beings.

In Arrabal's scheme of the human faculties, the memory is an integral part of man's imagination. The imaginative process does not give forth ideas, concepts, flights of fancy ex nihilo. Rather, the products of our imagination are based in part on what we have experienced and what our memory holds of this experience. But memory, as any reader of Proust knows, is frequently unpredictable, not only in content and form, but also in time. Arrabal seems to indicate that memory and the imagination are practically the same mental process; but whereas the first relies strictly on past experience and is an almost uncontrollable plunge into the past, the imagination can be just as secret a delving into the future. It hardly comes as a surprise, then, that one of Arrabal's basic axioms is that the future is realized in *coups de théâtre*.

Arrabal's interest in memory has direct consequences for his theater. This is especially true of his use of ritual as the basic structure and activity of a great number of his plays—even before his conception of panic. Ritual is commonly used by groups, religious and secular, to recall in some way important acts of the past so that they may have strength in the present and be ready for the future. Often among religious groups, the real meaning of the various activities that make up the rite is lost, but the intended effect still takes place. At times, even the language used during the ritual is no longer currently used.

The use of the ritual in the theater does not have the same commemorative goal it does in a religious context, but it does have the effect of resuscitating in the spectators certain emotions by means of creating a specific type of atmosphere. Arrabal realized the possibilities of the ritual for his theater very early in his career,

and it is no doubt one of the reasons that he chose the term "theater of ceremony" as an alternative to Panic Theater.

By his use of the ritual in his theater, Arrabal's debt to Antonin Artaud, the foremost avant-garde theoretician of the theater in the twentieth century, becomes clear. Artaud, in his essays collected under the title *The Theatre and Its Double,* urges playwrights to engage in re-creating a theater known to their ancestors—one based on myths in which the rite recalls man's more savage but not so noble tendencies. Artaud wrote of a theater that would touch man's innermost fibers and would resemble the ancient drama that was sensed and experienced directly by the mind without the deformation of language and the barrier of speech.[11]

In the nightmare world of his children, Arrabal created macabre rituals that not only gave form to some of his plays but provided for a continuing exorcism of his fantasies. In his panic plays, these rituals become more structured and more meaningful, since they provide for the frequent change of character, the mask, the game, and very often for the murder of some guilty yet innocent victim.

The grotesque character of Arrabal's plays has led some critics to call his works baroque. Although the term is a patent misnomer, since it properly belongs to the visual arts and by extension to the works of Góngora, Calderón, and the like, Arrabal feels that it has application to his theater. When asked to define "baroque," however, he took it in its most popular sense, for he thought that it was difficult to define its more profound aspects:

> For me baroque means very exactly a profusion that hides a very rigorous ordering of things, a solid architectural structure. More vaguely one can interpret the baroque as a lack of moderation . . . a lack of moderation in the sense that can be at the same time most disgusting and marvelous, excess—Beauty, through excess.[12]

Nevertheless, there are certain elements in Arrabal's theater that are analogous to the baroque style of the sixteenth and seventeenth centuries. Arrabal's emphasis on the theatricality of his works, his constant effort to make the spectators aware that they are in the theater, the rapid transformations of his characters—their polymor-

phism, if you will—his efforts to create or re-create the illusions and fantasies of his inner mind, his taste for the grotesque, and his penchant for the obscene and the erotic are characteristics that might be found variously in Shakespeare, Bosch, Agrippa d'Aubigné, Góngora, and other baroque artists. So the term is not completely abused in its application to Arrabal.

Fully realizing the historical ramifications of the term, Arrabal accepts it as one fitting his theater if it describes his incessant emphasis on the imaginative, the ritualistic, and the extreme. But he refuses to accept this classification if it divides or tends to divide the world into two separate categories—that of the real on the one hand and the imaginary on the other—because his theater aims at the discovery of the nightmarish, which is as real as any other aspect of the human condition. Interestingly enough, it is this baroque character, attained in part through the introduction of the ritual, that helps the spectator to examine his real self vis-à-vis the roles he plays and to examine the internal and private universe, which for Arrabal is the only "reality," as he pointed out to Alain Schifres in one of his interviews:

> Because it takes place on three levels: the grotesque, the sublime, and the ritualistic, my theater can throw some light on our investigation. Even the person who sees in my theater a demented work must necessarily ask himself certain questions; he must wonder if he is insane, or if it is more interesting to be wise or insane. In the same way that the Theater of the Absurd sheds light on the difficulty we have in communicating with words, the theater that I am defending sheds light on the problems we have with ourselves, all the fantasies, all our latent characteristics that we hide. It reveals that we are basically very different from our social appearance, quite distinct from our gestures.[13]

In the end, however, if panic is the all-embracing concept Arrabal desired it to be, it must be examined within the framework of his theater where his dreams, nightmares, and fantasies take form within his grotesquely comic and oneiric rituals.

Under the rubric of panic Arrabal placed five full-length plays:

*The Lay of Barabbas; The Architect and the Emperor of Assyria; The Garden of Earthly Delights;* and his panic opera, *Ars Amandi*. Also we find several playlets and happenings in his Panic Theater: *First Holy Communion, Impossible Loves, A Goat on a Cloud, Youth Illustrated, Has God Gone Mad?, Striptease of Jealousy,* and *The Four Cubes*. The full-length plays share the common features of an interrogation on the nature of love, on man's relationship with his fellows, and an extremely well regulated series of activities that compose a ritual or ceremony of sorts.

In *The Lay of Barabbas*,[14] Arrabal treats us to an initiation rite in which Giafar is introduced to "knowledge"—that is panic theory, love, and eroticism within the framework of dream sequences, orgiastic feasting, magic ceremonies, and erotic dancing. The other characters, Arlys and Sylda, the Father, the Mother, Kardo, and Malderic play a series of games in order to dupe their victim and lead him to knowledge. At times, the characters become so entranced by the games that they become the principal activity in this pseudocomedy of life. Dominique Loubet, in the introduction to the play, points out the triple role of these participants and their game playing: first, they perform the play as a simple comedy; second, together they fool Giafar in order to lead him to knowledge despite himself; last, they lose themselves in the games and play for the sake of playing.[15] This combination creates a theatrical texture of great richness and density, but its first effect is, to borrow a term from Arrabal, an apparent confusion and a seeming chaos.

The play begins with a knock on the door of an attic—a rather traditional opening for an avant-garde piece—and it closes in the same manner. In between a long series of games leads Giafar into the initiation rite and to knowledge of panic and life.

Because of the fast pace of the activities, the almost constant change of characters, place, and time, the play appears at first hermetically mysterious, but its construction is particularly rigorous and helps us to arrive at some understanding of it. All the dreams and ceremonies are carefully arranged in the play, beginning with Giafar's dream about his first encounter with Sylda, then Arlys's transformation of the attic from a baroquely awful place into a fairylike world, the ceremony of Sylda's birth, the sacrifice of Sylda, and finally the ceremony of Giafar's initiation. Each of these

scenes blurs the distinction between dream and reality as well as among the past, present, and future. Within each of these dream sequences there is some type of frenetic activity. For example, during Giafar's dreams he and Sylda play the card game, the lay of Barabbas, faster and faster, while Kardo and Malderic wildly jump up and down behind him. At the end of the scene in which Sylda is born, the Father dances about dressed like a blind man with dark glasses and cup, the Mother plays with her children's toys while tossing fish from her bed, Kardo does acrobatics, and Malderic pushes a baby carriage around the room—all this to the furious pounding of drums. Sylda's initiation scene ends with carnival music and the heavy erotic breathing of a woman. Even Sylda's transformation of the attic, which is very different from the other activities, since it is supposed to be performed in a "magical" way, is akin to the other scenes in that it takes Giafar and us one more step into unreality in a world already gone wild. After the transformation of the attic, an ostrich flies, the house flies hundreds of miles above the earth (like Dorothy's in *The Wizard of Oz*), and the door leading into the attic serves as a magic mirror as in Jean Cocteau's *Orpheus.*

The structure of the play is essentially circular. When Giafar knocks on the door and enters the attic, the various activities begin; after his initiation, another knock on the door signals the arrival of the next candidate. One can assume that the same activities will take place again. Most of the events have little logical rapport with each other except insofar as they are part of the entire initiation process. Arrabal, like many of his contemporaries, forsakes any dependence on a cause-and-effect relationship. It is the mere juxtaposition of events within a framework that represents their association, and it tends to make his theater pieces almost cinematic.

The alogical quality of the events in this play extends to the characters themselves. Sylda, the dark-haired and beautiful sorceress, is transformed into her opposite, Arlys—blonde, dressed in white, and despite her sexual promiscuity, innocent. Kardo and Malderic are sometimes childish, brazen, cruel, and voyeuristic. Sometimes they conduct themselves as adults and speak of symbolic logic and other erudite topics before becoming wildly danc-

ing dervishes. The Father sometimes speaks in the most grandiloquent and overblown language, sometimes in a sincere and calm tone. Giafar is the only character who offers some stability in this universe where transformations are a matter of course.

The polymorphism of the characters is part of the theatricality of the entire play. All of the characters act *as if* they were acting and play *as if* they were playing. Kardo and Malderic play at wrestling, at chess, at flagellating each other, at being children, at cards, at being Oriental potentates, at being blind, at being voyeurs. Sylda, of course, plays the role of the Sleeping Beauty at the very outset and then in the most extraordinary transformation of the play becomes Arlys, who changes the attic into a fairy kingdom. The Father, dressed in black opera cape and white tie, is a most theatrical personage. His costume and the fact that he plays the harp make him into a caricature of Harpo Marx in *A Night at the Opera*. His favorite role, however, is that of "savior," which he plays with Arlys, Kardo, and Malderic. The Mother transforms herself into Giafar's mother with the help of masks and costumes. Even Giafar plays the role of Prince Charming so as to awaken Sylda from her deathlike sleep. And we might assume that he plays at being initiated.

Occasionally the language of the play takes on a surrealist guise and adds to the sense of the theater, of illusion, of the unreal. Giafar says of Sylda: "She is very beautiful . . . she has white ankles that balance the music and the nest; she has hot hope and metallic desire. If she were living, you would see how nice it is to see her walk as if she were running toward the iron hand and the turbulent light." [16] Too, the baroquely furnished attic, since it is the setting for the action, is significant in a theatrical sense. Giafar says at the beginning of Sylda's birth scene that it is his own attic, that is a place into which he escapes into his own fantasies and where his own imagination runs wild.

Arrabal has placed within an illusionist frame the various transformations of his characters so as to accentuate the differences between the real and the illusory and to put emphasis on the performance, the event, the action that is taking place before us. In other plays, he has used quick transformations of his characters, but never within a context that grew out of a game—the game of

sheer performance that is presented here. In this play the primary activity is the initiation of Giafar to knowledge via love. To this end, the realities that are presented at the beginning of the play are abruptly changed, destroyed, or replaced several times in order to disorient Giafar. The transitions between these various segments of the performance are abrupt, and no preparation is given for them in the naturalistic sense. The intended effect is twofold: (1) Giafar's dependence on reality as he perceives it is called into question, and he is confronted by the chaos and confusion of the world he has stumbled upon; (2) the spectator's assumptions about reality are also put into question.

Yet despite the basic themes of birth, life, death, and resurrection that are introduced in the play, it never quite transcends its spectacular mise-en-scène. It remains a spectacle, maybe even an enjoyable spectacle, of wild dancing and of furtive trips into Giafar's mind, but in the end the play lacks focus. Nevertheless, it does represent an important step in the exorcism of Arrabal's own dreams and a liberation, if only tentative, from a complete reliance on the adult children of his earliest plays. In a sense, we have here a play that represents Arrabal's introduction into panic that permits him to take a less clinical and pathological look at love between the sexes. The play, however, does not truly allow that theatrical moment in which we can transcend ourselves and participate psychologically and emotionally in what we perceive before us, because it too frequently attempts to define the elusive concept of panic.

By the mid-1960s, Arrabal had become an enfant terrible of the new theater. His notoriety was enhanced by the presentation of his *Striptease of Jealousy* at the First Festival of Free Expression (1965) in Paris with Rita Renoir, the former striptease artist from the Crazy Horse Saloon, in its lead role. Despite Arrabal's membership in that fringe element of the theater that was willing to attempt new ways of making the ancient art a vibrant force in our social fabric, and despite praise from some critical quarters, Arrabal remained a minor playwright until the production of *The Architect and the Emperor of Assyria* in 1967. As Henri Gouhier said, "with this play, M. Arrabal has crossed one of the barriers on his way to the

government-supported theaters." [17] In fact, most critics, such as Robert Kanters of *L'Express,* although not extravagant in their praise of Arrabal's work, admitted that he had indeed given signs of his maturity with *The Architect.* "M. Arrabal," says Kanter, "is perhaps not yet a major writer, but with this play, he is learning to dissolve his fantasies and finally reach the age of manhood." [18]

This development in Arrabal's mastery of the art of the theater was not an easy task. It involved no less than fifteen years of work and a considerable amount of experimentation. Moreover, Arrabal had to learn to take himself seriously as a playwright. This change in attitude was brought about in part by his meeting with the panic group and his collaboration with the directors, Victor García, Jérôme Savary, and Jorge Lavelli, which gave him the opportunity to see his work produced by directors with whom he shared a common vision of the theater and the world.

In *The Architect,* Arrabal did not depart significantly from the themes of sadomasochism, love, cruelty, death, and torture that drew adverse critical reaction in his earlier plays. But his emphasis and treatment of the themes did change both in degree and in kind, and his translation of these themes into terms that are theatrically viable was more successful; he had learned to orchestrate his obsessions, fantasies, and memories within a well-structured form.

Like *The Lay of Barabbas, The Architect and the Emperor of Assyria* involves a series of games and ceremonies accompanied by the transformation of the characters. When the play opens, one hears the deafening noise of a jetliner about to crash into an island where the "savage" future Architect has lived for thousands of years. The Architect runs about wildly, trembling on his feet, and finally hides his head in the sand as the Emperor, carrying a suitcase, enters and announces that he is the sole survivor of the plane crash. When the second scene opens, two years have elapsed, and the Emperor is not so patiently trying to teach the Architect to properly pronounce his *s*'s. It is now that a series of games and transformations begins. The Emperor first plays the fiancée, then the Architect plays the Emperor's mother. When the Emperor in his turn decides to play the role of the mother, he does not whip

the Architect hard enough, so the Architect seizes the whip, flagellates himself, and leaves in a fit of pique. He returns only when the Emperor begins to cry melodramatically.

Upon the Architect's return, we find that he is not an ordinary native found by chance on a deserted island; he has tremendous powers. He can turn day into night or night into day simply by mumbling a few phrases; animals obey him, and birds do his bidding. These obvious powers do not, however, impress the Emperor. In fact, they seem to aggravate him more than they intrigue or astonish him.

During this act, the games continue unabated. The Emperor acts as if he were dying, and the Architect, who plays the doctor, assures him he is not. The Emperor dies just the same, and the Architect tries to bury him. The Emperor, as one might expect, becomes furious. Finally, the Emperor decides he wants to take up the religious life of a hermit. The Architect, disgruntled because he cannot lure the Emperor from his "house of prayer," quits the game and leaves the scene.

Once left alone, the Emperor is forced to play both himself and his partner. He sets up an image of himself on the throne and proceeds to play successively the Architect, a humble servant, a Carmelite nun, a mother giving birth, and a young man trying to prove that God exists by scoring a thousand points on a pinball machine. During these scenes we learn that the Architect is over two thousand years old and that the Emperor is a mountebank. He is not the Emperor of Assyria, just as he is not a Carmelite nun or an ape. When he starts to tell of his life in Assyria, he can never remember the exact details of an event, so he changes them at will. When he speaks of his life in another place and time as a minor bureaucrat, he reveals what is perhaps the truth:

*Emperor.* Of course at the end I didn't see much of my friends any more. . . . I had a lot of work to do, and I couldn't be bothered with them. When you slave eight hours a day and you take the train and then the subway, and . . . I didn't have any time for anything, and besides I had become indispensable. That's what my boss told me.[19]

Thus, we see that it is probable that all of the roles that the Emperor plays are fictional—including his role as Emperor.

In the second act, the transformations are closely related to one single activity: the trial of the Emperor for the murder of his mother. When the curtain rises, the Architect is acting as if he is taking apart some huge animal limb by limb. This is preparation for the last two scenes of this act when he will in fact eat the Emperor's body. The Architect, when he is finished this feigning, calls forth the Emperor and begins to play his role as judge. As the trial proceeds, these two will play all the witnesses. The Emperor becomes in turn his own wife, his brother, Samson, the president, and Olympia de Kant; the Architect, meanwhile, plays the Emperor's mother, a blind man, a dog, and the judge.

The various "witnesses" at this trial recount a great deal about the past life of the Emperor. They tell of his love-hate relationship with his mother, his masturbatory habits, and his erotic obsessions. We learn of the Emperor's dislike for God and of his penchant for the sacrilegious and the blasphemous. Finally, overwhelmed by his past, the Emperor admits that he killed his mother and the Architect-judge condemns him to death. The Emperor, as his last wish, asks that the Architect kill him with a hammer and eat his body so that he might be at the same time Emperor and Architect. "I want you . . . I want you . . . I want you to eat me . . . to eat me. I want you to be both you and me. You will eat my entire body, Architect, do you understand?" [20]

During the second scene, while the Architect devours the Emperor's body, he slowly takes on the characteristics of the Emperor. His voice changes and his expressions become those of the Emperor. His command over nature is lost, and the animals no longer obey him; but he has become the master of the Emperor's memory, his dreams, and his thoughts. When the transformation is complete, the play ends as it began. There is a deafening crash, and then the new Emperor arrives to report to a horrified Architect, his head in the sand, that he is the sole survivor of the accident.

The polymorphism of the two characters in this play constitutes the basic element of the piece, since their transformations support the structure of the play and serve to reveal the content through

the characters. Their function in the first act of the play is very similar to that of the games in *The Lay of Barabbas*—they introduce us to these characters as they reveal their fantasies through the game of mimicry. In the second act, the transformations for the most part reveal the obsessions of the Emperor, anchored as they are to the trial sequence that forms the central activity of that act.

Mimicry, one of the categories of games, involves the suspension of reality, a delimitation of time and space, subscription to certain conventions, and, at the same time, a great deal of liberty.[21] Unlike the games of *The Lay of Barabbas,* however, few rules govern the function of the activities in this play; rather, the two actors entertain each other by an incessant invention of a second reality. The characters play *as if* they are Emperor, blind man, ape, or what have you. This activity constitutes an attempt to disguise oneself or "forget" oneself behind the mask. Within this framework, normally there is no need to make the other person totally believe that one actually is the person one is playing, but the "actor" takes advantage of the atmosphere that the mask creates and its surrounding license. The actors create a sense of carnival and liberation, since from a psychological point of view the mask tends to disguise the conventional self and liberate the true personality.

When this game is taken seriously, that is, when a person disguises himself in order to deceive or when a person believes that his role or mask is real, the game ends. The person, in this case, is no longer acting *as if;* he is persuaded that he *is* the other and has completely lost himself behind the mask. This loss of real identity actually constitutes a form of alienation and is a corruption of the game of mimicry.[22] An example of such a phenomenon appears in the first act when the Emperor decides to chain himself and take up a life of religious meditation. Once inside his cabin, mumbling his prayers, he refuses to be disturbed by the entreaties of the Architect. The Emperor plays his roles seriously and is consequently left alone, for the game has ended. Once alone, he realizes that he not only alienated from the Architect but from himself, and he then sets up a figure of himself on his own throne.

These successive transformations allow Arrabal to introduce various themes into the play—in fact, as many as he wishes, because of

the flexible game structure. Although he treated some of these themes in earlier plays, here he takes a somewhat different perspective. The sadomasochistic theme, for instance, does not have the brooding, pathological overtones that pervade the lives of Cavanosa and his mother in *The Grand Ceremonial* or of Viloro and Tasla in *The Condemned Man's Bicycle*. Here he seems to be caricaturizing his earlier plays. For example, when the Emperor plays the role of mother and beats her Architect-son, her one casual slap with the whip is not adequate, so the Architect grabs the whip and flails himself.

In a political note, Arrabal introduces the ban-the-bomb theme. The Emperor, presumably the president of the United States, receives a call on the red telephone from his Russian counterpart, who is homosexual. The Architect-president has called to inform the Emperor-president that he has already pushed the button and that an H-bomb is about to reach its target. The Emperor-president, with supreme insouciance—like the parents in *Picnic on the Battlefield*—calls for an umbrella. When we next see the pair they have become apes, and one calls the other Papa Darwin. Arrabal is again playing blithely with the rather serious theme of man's self-destructive urges.

In another amusing episode, Arrabal treats the death-of-God theme. When the Architect leaves the Emperor, the latter, as already mentioned, continues his role playing to his alter ego. While dressed in a woman's bra and garter belt, he recounts the amazing story of how he bet on the existence of God by playing on a pinball machine:

*Emperor.* . . . do you know that I bet on the existence of God on a pinball machine. If I won one game out of three, God would exist. They were not difficult odds. And besides, I can handle those flippers with such ease . . . and it was a machine that I was used to. All the colors lit up with a flash. Here I am playing the first game; I have 670 points and I need a 1,000. . . . Ah! If the Architect were here, we would build Babylon again and its hanging gardens . . . 973 points, 973! [23]

When, as he says, he had God at his mercy and had run up 999 points, a drunk hit the machine and tilted it. Despite the accident, God did not exist.

In the scene following, Arrabal continues to make light of religious matters. Here the Emperor plays a Carmelite nun and her confessor. It seems the Carmelite had had an illicit sexual affair with an old man and has now come to seek pardon. The Emperor-confessor treats her horribly and tells her to come to his room that night for her penance.

The successive scenes in which the two characters play diverse roles creates a basically theatrical situation, since they are not only involved in role playing but wear masks and are costumed. The theatricality of the play helps to reinforce the illusion, permits the spectator to waver between the illusory and the real, and forces him to face up to reality—not reality on the level of the superficial masquerade of the games played here—but rather the reality of the profound drama that is the basis of this play. Jacques Guicharnaud points out the importance of the play of masks such as we see in this piece: "The play of masks leads to questions about life, theatre and their reciprocal relations. It is not the creation of a new art but the return with the help of new forms to a simple and ancient conception outside of which there is no theatre, only entertainment." [24]

In this type of theater, where theatricality is at the basis of the dramatic situation, the comic, which springs from the disparity between what is and what is expected, is naturally present. Arrabal uses an entire repertory of devices and procedures, but the principal one is the comedy of situation: a wild man on a deserted island finds himself confronted by a man who calls himself Emperor of Assyria, of whom he soon becomes both slave and pupil despite his own extraordinary powers. Besides being comically incongruous, the situation is not without precedent in literature; and therefore, it brings with it a rich series of associations, of which Robinson and Friday are not the least.

The constant change of characters and their incessant role playing lends a chaotic air to the play, since we never know what to expect next. In one scene in which the Emperor is seriously involved in a confrontation with the Architect, he suddenly becomes

president: "Tell me everything. . . . I am your father, your mother, I am everything to you . . . *(pause).* Just a moment. Someone is calling me on the red telephone. Yes, this is the president." [25] Likewise, in the pinball machine sequence, the Emperor stops in the middle of a truly exciting scene, turns to his image on the throne, and says in Mae West fashion, "How d'ya like my garter belt, fella?" [26]

Arrabal's use of the incongruous and the unexpected as the basis of his particular comic style reflects his vision of the universe placed under the combined signs of chaos and confusion. Since he believes that life without these two characteristics tends toward the inhuman, any truly human situation would perforce be confused, chaotic, and comic—although occasionally black.

This comic view of the world tinged with sarcasm does have several consequences. The objectivity that permits laughter also allows criticism. And Arrabal, along with the other writers of the avant-garde tradition from Alfred Jarry to Genet, criticizes modern society by presenting an image of it that truly mirrors its irrationality and, at times, it arationality only too well. The comic also serves as an antidote for some of his brooding pessimism and allows a glimmer of hope in the marginal world of his characters.

The morality of guilt and expiation presented in this play emphasizes and pinpoints Arrabal's pessimism. In the second act, the Architect-judge forces the Emperor to confess that he did indeed kill his mother. The Emperor then requests that the Architect participate in a most baroque execution and funeral ceremony. The Architect, dressed as the Emperor's mother, is to kill the Emperor with a hammer blow to the head and then eat his flesh in a final act of expiation. When the Architect-mother has finished the "meal," the play begins again.

The ritual of confession and expiation should result in the purification of the Emperor of his sins, but here these acts do not seem to be efficacious. Rather, we are confronted with a rather curious and ambiguous end that permits the action to begin again. The search for goodness and forgiveness that was the lot of Arrabal's adult children is also the spiritual impasse of the Architect and the Emperor. Here the games are more complicated, but the eternal quest nevertheless leads to a spiritual labyrinth.

Moreover, this last cannibalistic act of the Architect lends meaning to the play that transcends the sadomasochistic games of the Architect and the Emperor. When the Architect eats the flesh of the dead Emperor as asked, he performs an act analogous to that of the celebrant in the solemn liturgy of the Roman Catholic church who eats the flesh and blood of Christ under the form of bread and wine. For the Roman Catholic, communion is the most intimate contact with God; for the Architect, of course, it is also the most intimate contact with the Emperor, since it entails his very transformation into his partner. While commenting on the cannibalistic qualities involved in taking communion, Arrabal points out the real role that the sacred plays in this theater. Without it there would be neither the temptation of sacrilege nor the sacrilege itself. Given his own cultural and religious background, he is fully conscious of the rich dramatic possibilities of both.

The ritualistic and ceremonial aspects of the play are closely bound up with the religious themes and accentuate the theatricality of Arrabal's universe. The transformations during the first act and the cannibalistic communion that brings about the transformation of the Architect into the Emperor put into relief the theatrical aspects of the liturgy and the liturgical aspects of the theater. This alliance of the sacred and the profane and the liturgical and the theatrical shows Arrabal's debt to Genet, who so successfully uses these elements in *The Balcony*. Yet *The Architect* is not derivative and remains an original work of dense theatrical beauty.

Arrabal's originality in this play does not lie in the multiple transformations alone, nor does it lie in his language or in his use of comic procedures. Rather, it consists of his vision of man presented through his two characters. On one level, the Architect represents man who lives in harmony with nature and has a powerful control over it. He is indeed a noble savage. The Emperor, on the other hand, represents the accumulated knowledge of a civilization that gives him power over his own mind and the mind of others. On another level, the Architect represents the visceral and emotive aspects of man; the Emperor, the intellectual and the spiritual. They are, in effect, the complementary tendencies that make up the individual as well as humanity as a whole.

Given these opposite but complementary characters who pose as metaphors for us all, the spectator has a stake in the games they play. Not only does he see something of himself in these characters because of their universality, but he must realize that he cannot deny the existence of that complementary half. He must, then, accept himself as always in argument with himself, constantly playing out his game of life that leads to no conclusion but only to another beginning. If the play has a moral, it is that everything always begins again and that everything is to be done again. In this tragicomic situation, the spectator is both winner and loser, but he never wins or loses completely. Arrabal's image of man represented so successfully in the metaphor of the Architect and the Emperor has a cathartic effect upon the audience, since it represents the human condition in a concrete way. It is neither a situation without joy nor without sadness that obliges the Architect to chew on the bones of his fellow in one final act of love.

Arrabal tends to search among his own sexual fantasies and obsessions, his taboos and erotic nightmares, for the basic content of his theater. It is there in his internal universe that he truly finds his freedom. It is not surprising, then, that many of his characters live in a world of illusion along with other characters that are products of their own rich imaginations. This type of illusory *mise en abyme* we find in *The Architect and the Emperor of Assyria,* where the two characters are not only complementary but where each is likely the figment of one or the other's imagination. *The Garden of Earthly Delights* is another example of a play within the framework of illusion and thus stands as an exemplary expression of Arrabal's Panic Theater. It includes all the elements that now have become part of his repertory: the games, ceremonies, polymorphism of the characters, the sadomasochistic cruelty, and the love-hate relationship. The play, as Bernard Gille points out, is a delightful variation on the themes of *The Architect and the Emperor of Assyria,* with the added qualtiy of an inquisitional tone that tends to disturb the order of the games.[27]

Like the Emperor, her predecessor, Lais, the protagonist of the play, reveals her most secret life to us—both her past and her fantasies and obsessions. She is a retired actress, or so it seems, whose only contact with the world is the telephone. Surrounded by

her nine lambs, she lives, with her apelike companion, Zeno, in a world where little or no distinction is made between dream and reality.

The main activity in the first act involves a television interview in which Lais has agreed to participate, but only by telephone. Having agreed to answer questions posed by the spectators concerning her life and career, she reveals a considerable amount about her private life and her illusions. To one member of the television audience who asks her with whom she is living at the moment, she responds, "With my memories; my dreams, too. I speak to them and they live with me as if they were made of flesh and blood" [28]—a revelation of extreme importance for the entire play. Later she explains that her parents were a marvelous myth for her and that she feels quite sorry for those who must tolerate parents who are generally boring and banal. She also implies that she has committed a sadistic crime.

In another series of activities in the first act, we participate in Lais's dream world and her past. In these scenes she is joined by Miharca, a childhood friend, and Teloc, the panic man. Here, Lais is browbeaten by a nun played by Miharca; and, in complete idyllic liberty, she romps through flowered fields where she meets Teloc, who keeps his soul in a jar of pear preserves and has "ladders" that connect his head to his heart and his head to his abdomen.

The second act, like the first, is divided into scenes that deal with present "reality" and scenes situated largely in Lais's past. Again Lais's only contact with the outside world is the telephone. We see her first encounter with Teloc, who plays the trumpet, as did Emanou in *Automobile Graveyard*. The *ménage à trois* of Lais, Miharca, and Teloc is elaborated upon in this act, as we learn that both women love Teloc but that Teloc's real love is Miharca. In an act of sadistic revenge, Lais slaughters Miharca, first pulling out her eyes and then decapitating her by means of a guillotinelike device.

As the relationship between the different characters is explored, some transformations take place. Lais no longer treats Zeno as a child-animal. In fact, the relationship is reversed. By the end of the second act, the two characters, like the Architect and the Emperor,

have exchanged personae. Zeno eats Lais's soul, which is kept in a jar of preserves, and Lais becomes a child-animal able to speak only in monosyllables. The action concludes as Zeno and Lais rise to the heavens in an egg-shaped vehicle.

There is much in this play that is reminiscent of Arrabal's earlier plays, not only the themes of which this play is a variation but other elements of Arrabal's universe as well. For example, the labyrinth of columns that serves as the setting for *The Garden of Earthly Delights* reminds one of *The Labyrinth,* in which a maze of blankets serves as a metaphor for the complexity of man's psychic and oneiric world; Zeno's cage recalls several plays in which a character is imprisoned—namely *The Condemned Man's Bicycle* and *The Two Executioners*—and with it we are once again exposed to the themes of cruelty, sadism, and emotional imprisonment. Not the least of the elements that make reference to the whole canon of Arrabal are those he has borrowed from Hieronymus Bosch. The title itself shows Arrabal's preoccupation with the nightmare world of carnal desire and violence that is associated with Bosch. We find *The Schoolboys* of Brueghel, *Spring* by Botticelli, and *The Rock of Folly* by Bosch among the slide projections Arrabal's uses during the various dream sequences. These recall his panicky desire to throw the spectator into a world where confusion seems to reign but that is nevertheless a very structured world.

The panic element in this play is especially evident in the character of Lais, since she is in the act of becoming a panic woman. In effect, it is the movement from an ordinary to a panic woman that provides the action of the play or its goal in the sense that Francis Fergusson gives it.[29] At the outset, Lais is a woman lost in a dreamlike world of the past, surrounded by her lambs, and loved in a tenderly cruel fashion by Zeno. She speaks to her lambs as if they were her children; she is as innocent and as shy as the graceful young shepherdess whose costume she is wearing. Yet despite the fact that she is supposed to be a great actress, accustomed to appearing before large groups of people, she has singular difficulty in communicating with others on a personal level. But her initiation to a life of panic will completely transform her.

Besides the lambs, Lais cares for another animal in her life— Zeno, whom she keeps in a cage hanging from the ceiling of her

living quarters. Zeno, who has a fancy for flies and speaks in monosyllables, is more than a mere pet for Lais. Zeno is kept to satisfy Lais's sexual desires. He is the character Lais spoke of in response to a question from a member of the television audience: "and if one day I should like to become a woman, I should do so only with a monster or an exceptionally ugly man whom I would pay for his services." [30] Zeno fills the bill.

During the first act, Lais and Zeno play a series of games, the most important of which is getting married. Zeno is not the groom but the bride in this strange ceremony. Although ludicrously funny dressed in a bridal gown, this huge gorilla underlines Lais's need for love and affection and the comic-tragic proportions of her oneiric world. Between these two lost beings there develops a love-hate relationship akin to the relationship that evolves between the Architect and the Emperor, because it is obvious to both of them that they cannot survive emotionally without each other. Zeno's need for affection is just as great as Lais's, if not more so, because he cannot relate to anyone else. Consequently, in the love-hate battles no holds are barred for him. After one particularly nasty encounter between the two, Lais hoists his cage into the air. Stuttering, he communicates to her his need for tenderness and affection: "So . . . that . . . you . . . pay . . . more . . . attention . . . to me . . . I . . . I . . . am . . . shitting . . . on you. . . ." [31]

Alternating with the five scenes devoted to the development of the relationship between Lais and Zeno are five scenes in which Lais delves into her past life and exposes some of her experiences with the aid of Miharca, her childhood friend, and Teloc, the panic magician. Miharca plays the role of a vindictive and ruthless mother superior who literally imprisons Lais in her cell. Lais's desire for revenge bursts out in an adolescent scatological curse: "I'd like to throw everybody who makes me suffer into a . . . a . . . b . . . boiling cauldron of shit." [32]

When Lais and Miharca-mother superior pray together, they use a satirical version of Saint Francis of Assisi's prayer to the various elements of nature—one made no doubt familiar to Arrabal, when he studied with the Escalapios Fathers. It is a mocking tribute to the creations of modern technological society as much as a cynical view of prayer.

*Miharca.* The refrigerator.

*Miharca and Lais.* Blessed be my brother, the refrigerator, who keeps intact the fragile life of my sisters, the vitamins. Ah! if only I were as attentive in conserving life, as impermeable to corrupt ideas, conservative enough to honor healthy traditions.[33]

In the same scene, Miharca encounters Teloc, and the mocking attitude toward things religious continues. Teloc, who is not only a panic magician but a "petomane," asks Lais to sing Franz Schubert's *Ave Maria* while he accompanies her with his favorite activity.

We see reenacted Lais's first meeting with Teloc, which is the beginning of her liberation from convent school and an introduction to a new sort of life. Teloc tells her that she is as beautiful as the fields, the mountains, and the birds, that she sings her liberty through her eyes. This is the beginning of Lais's initiation into the world of panic, which will continue until the curtain falls. In order to hasten progress, Teloc allows her to don his magic helmet by which she can escape into the past or the future. When she pushes the button, she sees a series of images projected on the screen of her imagination: Superman and Lois Lane, the professor and the prostitute-singer from *The Blue Angel,* and the two lovers of Marc Chagall flash before her eyes, followed by scenes of the destruction of the Hundred Years' War and World War II, and of course by Bosch's *Garden of Earthly Delights.*

In the second act, we learn through a series of flashbacks, which constitute almost the entire act, how Lais came to change her attitude toward Zeno and how she was finally able to love this man-animal completely. Miharca and Teloc both play an important role in this transformation, and both help her to become a panic woman, that is, a person who is at peace with herself, who is whole.

The flashbacks show us what happened the night before Lais's phenomenal success at the theater. Teloc and Miharca arrive on the scene, and they relive some of the experiences of Lais's childhood. Once again the convent school and nuns play a prominent role. The threesome plays variations on a sadomasochistic theme. These games are played to one end only: that Lais may enter the

Garden of Earthly Delights. Miharca offers herself as a sacrificial victim in this essential but bloody prelude to Lais's consecration as a panic person. The situation is similar to the one found in *The Lay of Barabbas,* in which Giafar, the protagonist, is unwittingly guided through an initiation rite.

Each of the personages participating in this rite plays a specific role, and their names help to indicate the roles they play. Miharca is at once Lais's connection to the past—to her childhood experiences in the convent school and her meetings with Teloc—and her key to the future and a life of complete communion with the world about her. By sacrificing herself, Miharca brings about not only Lais's spectacular success in the theater but her liberation from the past. As her name indicates, Mi-h-arc-a is midway along an arc from the past to the future. She is a mediator.

Teloc, the panic magician, who is able to penetrate the past or the future, and whose heart, head, and viscera are connected by ladders, also has a name that indicates his activities or functions in the play. *Telos* is a Greek preposition based on an older word, *teleios,* which means complete or whole. It is Teloc, the high priest, who helps Lais celebrate herself, first by showing her that, no matter what, she is truly free, and then at the end of the play by showing her how to love in a most profound fashion, thus bringing her to "completeness." ·

Zeno's role in the actual initiation is kept to a minimum; he merely urges Lais to poke out Miharca's eyes from time to time. Nevertheless, his presence is symbolically important. Moreover, the fact that he and Lais exchange personae and become one in the egg at the end of the play points to the central theme of the unity of being and the search for unity. In this regard, the name Zeno is particularly significant. Zeno of Elea was a later disciple of Parmenides of the fifth century B.C. He denied multiplicity, movement, and temporality; and like his master, he held the existence of the one to the exclusion of the many. Zeno was particularly known for his conundrums and for his argument by which he used to try to prove the impossibility of motion. Consequently, he had a reputation as a clever riddler. But like Arrabal, describing the fanciful tenets of his panic theory, Zeno was quite serious. Although he denied the reality of multiplicity and motion, Zeno did

not deny that we sense motion and multiplicity. He merely declared that what we sense is illusion—mere appearance.[34]

The Zeno of the play is, of course, far from a philosopher, but his name evokes that of Zeno of Elea and draws our attention to Arrabal's intention to treat the problem of unity and multiplicity. Moreover, the theme of illusion, always present in Arrabal's ceremonies, becomes a part of the central theme of the search for unity, and it emphasizes quite strongly the illusory world that Lais has constructed for herself; the world of Lais the actress, and Lais the lover of Zeno. But the illusion also throws into question all the changes that take place in Lais: her transformation from an ordinary to a panic woman, as well as her transformation from a convent school girl to a great actress. The illusions, then, are multiplied on several levels in order to create a play of great richness.

The name Lais refers first to the female protagonist of the entire canon of Arrabal's work, since it is a variation of Lys, the name of the primal female of Arrabal's universe. There is also the obvious reference to Lais, the celebrated courtesan of Greek antiquity, renowned for her extraordinary beauty and intelligence. Since Lais is supposed to be an actress known for her beauty and talent, the name fits her well.

As already mentioned, this play contains many of the themes Arrabal developed since his debut as a playwright. Perhaps even more important, it also contains certain structural techniques with which Arrabal has experimented during his career. In *Concert in an Egg* (1958), he divided the play into two series of scenes, the first of which was apparently independent of the second. Upon examination, however, the two series of scenes fit into a pattern. This attempt to present two sets of scenes, independent but complementary, was not successful, because the time structure of the piece was muddled and the connecting elements between the two series were not always clearly expressed in theatrically viable terms. Although Arrabal never again tried to combine two apparently independent series of scenes by transforming his characters, he continued to experiment with the time structure in several plays, notably in *The Lay of Barabbas* and *The Architect and the Emperor of Assyria*. In *The Garden of Earthly Delights,* however, he quite successfully manipu-

lates both the time texture and the structure of the play without losing his audience in a barrage of visual and auditory effects.

The first act, divided into ten scenes, alternates between the past and the present as the life of Lais unfolds before us. The alterna-. tion prepares us for the second act, when Lais is projected into the future with the help of Teloc's magic helmet, the future of her enormous success as an actress. The descent into Lais's past and her fantasy life, followed by her projection into the future, create a kaleidoscopic effect similar to that created in the film by the use of flashbacks and quick cutting. Its use in the theater is not as common, since it creates problems of organization that are difficult to overcome. Previous to this play, Arrabal did not always succeed in creating this kaleidoscopic panic effect without losing control of the thrust of his play. Here, however, he demonstrates that he has learned to orchestrate the various elements admirably. This is particularly true of the second act, which presents an alternation between scenes that take place the day before Lais's resounding success in the theater and those that take place the day after— presumably the present. Intermingled with these scenes are brief forays into the more distant past when Lais and Miharca are once again schoolgirls. The gradual merging of the near past and the much more distant past with the present that takes place during the initiation ritual completely blots out any distinction between past and present by the time Lais and Zeno enter the Garden of Earthly Delights at the end of the play. Add to this formula the various transformations of the characters because of the change in time and the visual effects of the flashing slide projections, and we have the wonderful world of illusion and appearance that we call theater.

These structural elements, however, are not divorced from the thematic elements, for the gradual loss of distinction between past and present complements the theme of the search for unity that constitutes the real goal of Lais's liberation from the past. She is not only liberated from the past; she also finds a unity in her earthly paradise that escapes Arrabal's other characters. Even the Architect, although he has devoured the Emperor, does not find that profound unity that is the quest of all human beings, since the action at the end of the play recapitulates that of the beginning. In

*The Garden of Earthly Delights,* the action does not begin again in a sterile repetition, for Lais rises into the heaven with Zeno; she has become the perfect hermaphrodite.[35]

As with all the major plays of Arrabal's panic theater the baroque is one of *The Garden*'s outstanding characteristics. First, there is the ever present taste for violence and horror that figures in the murder-sacrifice of Miharca as well as in the scenes depicting the struggle between Lais and Miharca during which Miharca plucks out Lais's eyes and tears off her ears. In addition, the various and frequent transformations of the characters emphasize the illusory and theatrical aspects of the baroque. The transformation of Miharca into the mother superior and Lais into a young girl and the transformation of Lais into a gorilla and Zeno into a handsome human are good illustrations of Arrabal's adventure into the baroquely grotesque.

The illusory is particularly apparent in the character of Lais, who lives with her memories and dreams "as if they were flesh and blood." In the first act, the alternating scenes usually propel us into Lais's past or into her fantasy life. Moreover, the possibility exists that all of the other characters—Teloc, Miharca, and Zeno—are merely figments of Lais's imagination or the various expressions of the one and the same being.[36]

The fact that Lais is an actress, that is, a person who plays a role and tries to create an illusion, serves as the foundation for the structure of theatricality in this play. One sees her playing *as if* when she speaks to the television audience or the announcer. She is not then Lais the lover of Zeno or Lais the schoolgirl, but the Lais her fans want her to be. In short, she is playing at being an actress. Thus, we see an actress who is playing an actress who is playing an actress, and so on—a theatrical *mise en abyme.*

Though the theatricality of the play revolves principally about Lais, it also includes Teloc, the trumpeter and panic magician, and Miharca, who continually evolves into characters from Lais's past. Even Zeno is reminiscent of King Kong, or of any of the amiable but frightful monsters of the Hollywood films of the 1930s and 1940s. Also, the secondary production aspects of the play tend to heighten its theatrical atmosphere: a revolving stage brings Lais's lambs on and off the stage; the lighting effects called for are

numerous, especially during Lais's excursions into the past or future that are punctuated by slide projections of battle scenes and of paintings by Bosch, Brueghel, and Goya, in the same manner as that other exercise in exorcism, *The Lay of Barabbas.*

The use of projections, bizarre lighting effects, even the revolving stage recalls Brecht's use of these secondary production elements in order to create a *Verfremdungseffekt* in a conscious effort to make the spectator aware of being in the theater.[37] Arrabal uses these elements to the same end, but even more specifically to make the spectator aware of himself as a role player. For Arrabal is preoccupied with the distinction between the role one plays and the real self.

Certainly within the context of this play, in which the protagonist is an actress, Arrabal also touches upon the related question of the rapport between life and the theater—a question treated by many of the major dramatists of the twentieth century, notably Luigi Pirandello, Genet, Beckett, and Ionesco. Life, these dramatists tell us, invades the theater just as the theater invades life, so that a never ending series of mirrorlike reflections results in a blurring of the distinction between the two. In this play, Lais's role playing in the theater and in "real" life, her descent into her own past, and her journey into her fantasy world substantially reduce the distinction between life and the theater. Some of the scenes in the prison cell of Lais's convent school draw on Arrabal's own prison experience in Spain in 1967 before he finished work on this play. Some critics think that these scenes tend to upset the order of the games played by these characters and constitute a flaw in the continuity of the play's texture.[38]

Nevertheless, *The Garden of Earthly Delights* represents an important step in the development of Arrabal's theatrical art: he has learned to successfully harmonize elements of his own fantasy life and that of his characters within the framework of a baroque ritual, and he has finally led one of his characters to an earthly paradise by means of his panic ritual. As such, the play stands as a definitive statement and a considerable triumph in Arrabal's brand of theater.

From the semijocular statements of his essay on "The Panic Man," Arrabal has developed, on the one hand, a unique and all-

encompassing world view, and on the other hand, a theater that revels in the game of pure performance, oneiric ritual, grotesque transformations, and sublime sacrilege. Most important, however, is Arrabal's insistence on the eclectic nature of man; on man's multiplicity; and on man's profound freedom, which is never totally stamped out even when he is oppressed. It is Arrabal's insistence on man's liberty to dream what he will, to allow his own phantasms the freedom that society will not, that mark Arrabal's work and that make them at once both fascinating and frightening.

## Notes

1. Françoise Raymond-Mundschau, *Arrabal* (Paris: Editions universitaires, 1972), p. 21.
2. Geneviève Serreau, "Un nouveau style comique, Arrabal," *Les Lettres nouvelles* (November 1958); also appeared in *Evergreen Review* 4 November-December 1960): 61-69.
3. Raymond-Mundschau, p. 22 All translations are mine unless otherwise noted.
4. Fernando Arrabal, "Textes paniques," *La Brèche 1* (September 1962).
5. Fernando Arrabal, "El Hombre Pánico," *Primer acto* (Madrid: Ediciónes Taurus 1968); pp. 27-37.
6. Fernando Arrabal, *Théâtre panique* (Paris: Christian Bourgois, 1967), p. 8.
7. Arrabal, "El Hombre Pánico," p. 29.
8. Ibid., p. 31.
9. Ibid., p. 33.
10. Ibid., p. 34.
11. Antonin Artaud, *The Theatre and Its Double*, trans. Mary Caroline Richards (New York: Grove Press, 1958).
12. Alain Schifres, *Entretiens avec Arrabal* (Paris: Pierre Belfond, 1968), p. 60.
13. Ibid., pp. 114-15.
14. Fernando Arrabal, *Théâtre 4* (Paris: Christian Bourgois, 1969).
15. Ibid., p. 20.
16. Ibid., p. 28.
17. Henri Gouhier, "Théâtre populaire: le cas d'Arrabal," *La Table ronde* 232 (May 1967): 127.
18. Robert Kanters, "L'Ivresse râpeuse d'Arrabal," *L'Express*, March 20-28, 1967, pp. 67-68.
19. Arrabal, *Théâtre panique*, p. 122.
20. Ibid., p. 185.

21. Roger Caillois, *Les Jeux et les hommes* (Paris: Editions Gallimard, 1958), pp. 32-33.
22. Ibid., p. 111.
23. Arrabal, *Théâtre panique,* pp. 127-28.
24. Jacques Guicharnaud, *Modern French Theatre* (New Haven: Yale University Press, 1961), p. 16.
25. Arrabal, *Théâtre panique,* p. 108.
26. Ibid., p. 127.
27. Bernard Gille, *Fernando Arrabal* (Paris: Seghers, 1970), p. 101.
28. Fernando Arrabal, *Théâtre 6* (Christian Bourgois, 1969), p. 22
29. Francis Fergusson, *The Idea of a Theatre* (Princeton: Princeton University Press, 1949), p. 230.
30. Arrabal, *Théâtre 6,* p. 57.
31. Ibid., p. 75.
32. Ibid., p. 26.
33. Ibid., p. 31
34. Frederick Copleston, S.J., *A History of Philosophy,* vol. 1, part 1 (Garden City N.Y.: Image Books, 1956), p. 76.
35. Camille Amary, "Le Jardin des délices," in Arrabal, *Théâtre 6,* p. 12.
36. Ibid., p. 11.
37. Ruby Cohn, *Currents in Modern Drama* (Bloomington: Indiana University Press, 1970), p. 208.
38. Gille, p. 101.

# 3.

## The Theater of Illusion, Games, and Ritual

Intrigued by his own childhood, adept at sounding his own fantasy life, and constantly fascinated by the theater, Arrabal has incorporated into his plays a curious amalgam of illusion, games, and ritual that combine to form a magic kaleidoscope of images that are at once shocking and beautiful. These elements help to distinguish Arrabal's theater from the traditional theater that depends to a great extent on the opposition of protagonist and antagonist within the framework of a story and the resultant tension and denouement. In Arrabal's theater, as in much of the "new" theater, stories give way to games and their attendant rules; plot is replaced by rhythms and transformations; cause-and-effect relationships give way to juxtapostion of disparate elements; sequential time frequently yields to circular time; and resolution of conflict becomes an indeterminate repetition.[1]

Arrabal is not alone among the absurdist or postabsurdist dramatists who depend on these elements as both structuring and thematic forces in their plays, but he relies on them more than most and uses them with uncommon insistence and bravura. His

use of them is meaningful for two reasons: (1) they are a part of his creative process, and (2) they figure in the plays themselves.

The creative process is an essentially inner-oriented activity that involves the unconscious, the subconscious, memories, and the imagination, from which the artist develops the images, the dreams, and the illusions that make up his working repertory of ideas and forms. It is within this framework that the artist finds freedom from the work-oriented world of economic realities that are dominated, in Freudian terms, by the reality principle. Without yielding entirely to the overpowering force of reality during the creative process, the artist can draw from it those forms that are in conjunction with his dreams. In effect, he can re-create the world in conformity to his dreams and fantasies and represent a world as he would want it. This process is both liberated and liberating, and it is the one area of human existence that refuses to submit to oppression of the outside world, whether it is social or political.

Arrabal is acutely aware of the role that his fantasy life plays in the re-creative process. As a native of Franco's Spain, he has seen the iron fist of political oppression and has felt the chains of the obsessions of hate, sin, death, and sexuality that bind that nation to vestiges of other eras. His own retreat into his world of fantasies and illusions, as an escape from such strictures, is wonderfully illustrated in his autobiographical novel, *Baal Babylone,* and the movie, *Viva la Muerte,* which is based on the novel.

It should come as no surprise that during his own re-creative process, Arrabal frequently places his characters within an illusional frame, as he did in *The Lay of Barabbas, The Architect and the Emperor of Assyria,* and *The Garden of Earthly Delights.* In these plays, the dreams and illusions of the characters not only provide the setting and themes of the play but are truly extensions of Arrabal's own fantasies. The tension in the characters' lives arises from the conflict between the self-assertive quality of their illusions and dreams and the oppressive character of the world of reality.

In *The Lay of Barabbas,* Giafar imagines that he is in his own attic where the activities of the play take place. The attic, whether real or imagined, is an apt image for Giafar's mind, where Arlys-Sylda, the Mother, the Father, Kardo, and Malderic represent all of his dreams, fears, and neuroses. It is there within himself that Giafar is

led to an understanding of himself and to panic. Thus, we find an externalization in a theatrical but vicarious way of Arrabal's illusions and fears, since Giafar is both Arrabal's creation and his alter ego.

Unlike most human activities, illusions, fantasies, and dreams have no set rules, no limits. They may take place within a framework that is the construct of the creator-artist, in a place that may resemble reality but is not. The place, in *The Lay of Barabbas,* is an attic resembling Giafar's own at the outset, but it is quickly transformed into a fairy kingdom by Arlys-Sylda. The time sequence of the entire play has little to do with the chronological time of the real world and becomes the symbolic time of the exorcism that Giafar is undergoing. The only controlling factor in a temporal sense is that all of the activities must take place before Giafar's initiation is terminated. The knock on the door at the beginning of the play signals the beginning of the activities; his departure signals their termination. In a sense, all of the activities that take place—the games, the wild dancing, and so on—are essentially nonproductive. They are set apart from work and are performed for their own sake and for the pleasure of the participants. In effect, everything about this play is extra-ordinary, separated from daily life and the strict confines of productivity (work) and chronological time.

In a similar vein, Lais, in *The Garden of Earthly Delights,* lives in a world of self-created and self-inflicted illusion. As an actress, she is a creator of illusions for her audiences—and a good one, evidently. But she is also a woman who is able to create illusions for herself. The world she lives in, surrounded by her lambs, is peopled by Teloc, the panic magician, himself an illusion and a creator of illusions; by Miharca, who represents in various guises Lais's past; and by Zeno, her lover-gorilla, who represents not only her sexual fantasies but also her fears and nightmares. More than in *The Lay of Barabbas,* the outside world impinges upon Lais's self-created world. But the television announcer and the audience are perceived here only as voices—at long distance, so to speak.

The illusion and dream are not confined only to the plays of the Panic Theater. In Cavanosa of *The Grand Ceremonial,* we find a character who lives in the world of his masturbatory fantasies, which he tries to actualize each day as he pursues and woos an

unwitting victim in his sadomasochistic games. His fantasies are visually represented by the life-sized dolls strewn about his apartment on which he vents his pent-up sexual energies. Jerome and Vincent in *Ceremony for a Murdered Black* live out their illusions within a theatrical framework. Their desire to be great actors leads them at first to accept Luce into their illusory world of costumes and playacting and eventually to murder the black Francis of Assisi for smashing their illusion and breaking the rules of the game. Once the illusion is dissipated, the police, as representatives of the real world, descend upon them with vengance.

Jerome and Vincent are typical of Arrabal's adult children in that they lose themselves in their theatrical illusion almost to the exclusion of all else. They remain adults, but they play as children. In his study of the play element in culture, John Huizinga describes this aspect of the child's world:

> We know, however, that [in] child-life performances of this kind are full of imagination. The child is *making an image* of something different, something more beautiful, or more sublime, or more dangerous than what he usually *is*. One is a prince, or one is Daddy or a wicked witch or a tiger. The child is quite literally "beside himself" with delight, transported beyond himself to such an extent that he almost believes he actually is such and such a thing, without, however, wholly losing consciousness of "ordinary reality." His representation is not so much a sham-reality as a realization in appearance: "imagination" in the original sense of the word.[2]

It is exactly this type of world that Arrabal's characters slip in and out of so easily. However, their hold on ordinary reality seems to be less firm that that of the children described by Huizinga. Moreover, it should be noted that the world of illusion that these characters create is a very theatrical one, both from the point of view of the inner structure of the plays and from the point of view of the audience.

Illusion, when actualized and given rules and structure, becomes game. Under this guise, it still remains a free activity consciously divorced from the daily life of work, since it is neither serious nor

productive. However, it tends to order the activities within certain boundaries of time and space. And unlike fantasy or illusion, which tends to be solitary, the game promotes "the formation of social groupings which tend to surround themselves with secrecy and to stress their differences from the common world by disguise or other means." [3] In effect, while adding structure and form to illusion, the game permits the individual to participate in a communal illusion. Parenthetically it should be noted that the easy passage from illusion to game is demonstrated by the close association of the word illusion to the Latin verb *ludere* (to play).

Some of the games Arrabal's characters play can be classified according to their structuring elements. Games of competition such as running, wrestling, fighting, and word games fill the idle hours of the adult children of his early plays. Games of chance and games of mimicry especially make their appearance in his Panic Theater.

In *The Tricycle*, the competitive word games of Climando and the Old Man tend to reinforce the child-adult metaphor, for they incorporate the type of challenge game children play in order to prove their endurance is greater than that of their playmates. For Climando and the Old Man these long word parries are outward signs of the more subtle sadomasochistic struggle that is the basis of their relationship. Further, the game, once played, can always begin again with a new topic, thus becoming a continual matching of wits as well as a way of relieving boredom. These tests of linguistic strength usually begin with a reasonable remark and then become a series of non sequiturs the Old Man can no longer deal with:

*Old Man.* Well, how ya doin', boys! I'm gonna sit down here. I'm so tired I couldn't do a stitch more work.
*Climando.* That's the way I feel, too. (*Climando stretches out near the river and the Old Flute Player sits on the bench. Long Pause.*)
*Old Man.* That's because of the cart.
*Climando.* What's that?
*Old Man.* The reason you're tired.
*Climando.* Gosh! I spent the whole afternoon carrying those kids around. I'm really sore under my arms.

*Old Man.* That's from your suspenders. The same thing happens to me. From playing the flute, my knees get sore.
   *(They both start speaking rapidly.)*
*Climando.* That's from your hat. The same thing happens to me. From fasting, my nails get sore.
*Old Man (very angry).* That's from buying lottery tickets. The same thing happens to me. From walking, all the hair on my head is sore.
*Climando (very happy).* That's not true! That's not true!
*Old Man.* It's not true?
*Climando.* No. No. It's not true. The hairs on your head can't be sore, because you're bald.[4]

In almost every case, these linguistic skirmishes lead to anger, accusations, counteraccusations, and then to the game of pardon in which Climando must beg forgiveness for having treated the Old Man badly. Once pardon is asked for and accepted, they can continue their activities until the next round of word games. Although Climando proves his superiority in these contests, he must always beg pardon so that the air is cleared, the slate is clean, and the game can begin again.

Within the illusionist framework of *The Lay of Barabbas,* Giafar, the novice who is being initiated into the knowledge of panic theory, is a sometimes unwitting partner in the games played by the other characters. Besides the agonistic games of arm wrestling and running, he also participates in the game of chance after which this play is entitled. According to the rules set down by Sylda, one must obtain either a seven or several cards that add up to seven, the magic number. This game, accompanied by the frenetic pounding of drums, is played faster and faster until a winner declares himself. The winner then takes possession of the loser as his or her slave. Given the nature of the winner's "purse," the lay of Barabbas reinforces the games of sadomasochistic cruelty that are essential elements in Giafar's initiation rite.

Besides their significance as performance activities within the theatrical framework of a theater piece, these games of competition and chance gather import from the cultural framework of modern Western civilization. The game, as Huizinga indicates in his study,

precedes culture and is at the same time a civilizing force.[5] Within the context of agonistic play, the concepts of honor, virtue, and superiority are developed. The winner in such games generally gains the praise and adulation of his fellows, and by association with him the whole group is honored. This traditional effect, however, must be considered within the social rules of the adult children. For instance, when Climando beats the Old Man, instead of winning praise from his friends he must beg pardon for offending him—for beating him at his own game—even though it is the Old Man who always throws down the gauntlet. Climando's victory in every case is twofold: he must suppress his internal drive to win these battles completely—which he does—and he gets the praise he is looking for only by admitting he has lost. This second act is external in that it is socially oriented, since it reinforces the rules and permits the game to continue. Here again the game not so subtly masks the ongoing master-slave relationship.

In Arrabal's works, these games of chance and contest form a part of the spectacle both for us and for the other characters. In *Automobile Graveyard* when Tiossido and Lasca, two athletes turned policemen, begin to chase Emanou and his three companions, the chase itself becomes the center of attraction. All of the characters become completely engrossed in it either as participants or as spectators, since suspense concerning the outcome of the race is inevitable. Even Emanou, who in reality is running for his life, perceives the race as a playful romp. In effect, their identification with Emanou, who is a hero for this deprived group of adult-children voyeurs, is so strong that a second level of reality is created within the play that leaves them "beside themselves" with excitement and fear.

The other classification of games—mimicry—is of particular interest here because it belongs essentially to the theater and the spectacle. Mimicry consists of an incessant invention of a second reality with which the actor who is usually disguised literally charms the spectator who is invited to believe in this illusion as being more real than reality itself.[6] Arrabal's theater, based so firmly on the illusion, an essential element of all games, is permeated by characters who amuse themselves by playing at being someone else. Nowhere is this more obvious than in *The Architect*

*and the Emperor of Assyria.* The entire play is in fact a creation of a second reality by the two characters, whose sole pastime is the game of mimicry.

As with all games, mimicry has its rules. The main rule allows the suspension of reality for a certain time during which the disguised person acts out his assigned role. Many variations on the theme pervade the theater and the music hall. However, whenever the player stops acting *as if* and starts to believe that he *is* whatever he is playing, the real goal of the game is corrupted. There takes place a subtle change in his relationship with the other performers and with the onlookers. The player who dares to corrupt the game in this way is alienated; he is no longer participating in a communal illusion but only in his own particular illusion. In the same way, whenever reality is imposed on the game of mimicry by a deliberate attempt at deception such as by a spy or a disguised fugitive, the game is corrupted.[7] This latter sort of corruption is in fact at the basis of *The Architect and the Emperor of Assyria,* since as the play progresses we find that the Emperor was actually a minor bureaucrat in whatever his country of origin, but like many invading Western colonializers, he imposes his power upon the ignorant but far from powerless Architect. Indeed, we learn that the Emperor is a fugitive from the law. He killed his mother with a hammer blow to the head and then escaped on the plane that crashed on the Architect's island. His fugitive status sets up the entire trial scene in the second act of the play.

Likewise, the spoilsport who refuses to play or stops the play is another variation Arrabal uses in his theater games. The spoilsport, however, is considered more reprehensible, for, unlike the cheat who continues to support the illusionist frame of the game, the spoilsport breaks the illusion and ruins the game for all concerned.[8] Given the murderous character of Arrabal's players, even the semblance of being a spoilsport has mortal consequences. In *Fando and Lis,* Lis readily participates in all of the blatantly sadomasochistic games that Fando revels in, but a false move, when she is chained and handcuffed, causes her to tear Fando's drum—an important part of his childhood world. The result is a fatal beating. In *The Grand Ceremonial,* Cavanosa, also enamored of sadomasochistic games, completely rejects Sil, who desperately

loves him, because she does not play the game. And in *Ceremony for a Murdered Black,* the black Francis of Assisi is done in by Jerome and Vincent because he breaks the illusion of Luce's purity and innocence by sleeping with her.

Considered purely as performance activities, that is, as elements employed by Arrabal to create certain effects and to structure his plays, the games his characters play take on added import. To replace the story that is common in the traditional theater, they provide a different type of relationship among the actors-players and between the actors and the audience; they tend to set up a different standard of time; they organize space differently; and they lend value to the objects used in the game.

An extreme example of the game as a performance activity within Arrabal's canon is *Theatrical Orchestration,* or *God Tempted by Mathematics,*[9] in which there is no plot, dialogue, or even juxtaposition of meaningful images. Instead, the piece is composed of the movements of inanimate objects in an exacting, rhythmical manner. This spectacle is divided into four scenes entitled "Movement," "Kaleidoscope," "Rhythm," and "Composition." In each of the scenes, Arrabal uses panels painted in various hues, their reverse side a mirror; balls, also painted various colors, which hop along stairlike devices; or mobiles of different shapes and sizes. All these variously shaped objects have carefully prescribed movements. Whenever an actor is required to turn the panels or mobiles, he is to be expressionless and is supposed to move mechanically. In this experiment, Arrabal is playing with the traditionally secondary theatrical elements of scenery, lighting, props, and sound—and their interreaction—instead of using them to *support* a performance. He has made them the performers; and their movements, all carefully calculated, become the performance itself.

*The Four Cubes,*[10] another experimental piece in the same vein, relies to a greater degree on the human element, but here again there is no dialogue, and the plot is really a series of games. The two actors, A and B, move four large one-meter cubes onto the playing area; they play on and around the cubes and eventually disappear within them. The cubes, painted with designs a la Piet Mondrian and Paul Klee, are equipped with trapdoors on their upper surface and sides so that the actors can enter or fall into

them and, once inside them, can move from one cube to another. All the games A and B play are carefully choreographed. They include a game of leapfrog during which A falls inside one of the cubes and is imprisoned, a game of hide-and-seek in which B unsuccessfully tries to find A, and several other children's games that come to an end when A and B definitively disappear within their cubes. Unlike the situation in *God Tempted by Mathematics,* here there is a meaningful relationship between two characters who play the games assigned to them by the script. Not surprisingly, their miming shows that they are inextricably bound to each other in the weak-strong, masculine-feminine relationship of other Arrabalian couples.

Besides providing a structure of activities for some of Arrabal's spectacles, games also allow variations in the temporal makeup of his plays. Linear sequence of activities is the most common of the temporal modes used by playwrights, especially those working in a naturalistic framework. The avant-garde playwrights, however, tend to break the hold of the logical ordering of events within a sequential time scheme and to play with time in order to portray the inner workings of the mind and the subconscious. Arrabal has not been impervious to this development in the theater arts, as we see, for example, in *The Garden of Earthly Delights.* Lais is at once plunged into her schoolgirl past and into the future with the aid of her two panic friends, Teloc and Miharca. The first act of the play is divided into ten scenes alternating between past and present; the second act, into scenes that take her into the past and the future. Arrabal thus obliterates any sequential time pattern. No doubt he is influenced by the film, in which flashbacks and cutting can create logical and temporal jumps without marring the overall aesthetic effect. From a purely theatrical point of view, however, two time patterns take hold in this play: (1) there is the time it takes to turn the script into performance; (2) there is the symbolic time of the performance that the audience must accept in order to participate fully in the theatrical event. Although this is true of all performances, Arrabal makes particular demands on his audience by creating a rich temporal mélange within an illusionist framework.

Another permutation of the temporal structure Arrabal fre-

quently and effectively uses is circular time. Since many of his plays depend on a repetition and intensification of various activities or events that lead to an emotional outburst that culminates in murder, a type of spiraling structure of events is established. *Fando and Lis* and *The Condemned Man's Bicycle* both include an intensification of sadomasochistic cruelty that ends with the murder of the innocent-but-guilty victim. Other plays, however establish a pattern of intensification and add to it a recapitulation of the activity. *The Architect and the Emperor of Assyria* illustrates this pattern perfectly. The pattern of games of mimicry is seemingly ended when the Architect kills the Emperor and then ritually feasts on his remains. But the double transformation of the Emperor into the Architect and vice versa resets the mechanism for a complete recapitulation of the events. A circular pattern is established that will continue, so it seems, ad infinitum. In a similar manner, *The Lay of Barabbas* ends as it began, with a knock on the attic door and the arrival of a "new" Giafar, who is to be initiated into love and panic.

This circular quality also pervades *The Grand Ceremonial,* but with a variation on the theme. Cavanosa's daily excursion into the real world of the park sets up a pattern of wooing, ritual dressing, and murder of his newfound victim. This pattern mechanistically runs its course every day beginning at dusk. Time here is the cue for the beginning of the activities that always end in the same way. Sil and Lys, however, upset the pattern and establish a new permutation in Cavanosa's game plan. Nevertheless, even within the permutations, it is time that serves as a signal for the beginning of the action. At dusk Cavanosa goes to the park, woos and wins a young female victim, goes to the apartment, and blinks the lights three times to signal his partner's entrance and the beginning of the sacrificial rite. Time in Cavanosa's world does not bring about changes as it does in the traditional theater; it cues another step in the set of events.[11]

The circular nature of the temporal structure of Arrabal's plays frequently is reinforced by the activities of the game-loving characters. In their search for Tar, the earthly paradise of Fando's and Lis's dreams, these two forlorn characters daily trace a circle in their marginal world and end where they began. For Mitaro, Toso,

and Namur, it is the same. Moreover, their daily search is punctuated by their eternal return to the conclusion that they cannot reach Tar because they do not take the "proper precautions":

*Mitaro.* The same thing happens to us. No matter how we try to reach Tar, we always end up in the same place.

*Namur.* But the most difficult problem we encounter, the worst problem, is that we never take the proper precautions.

*Mitaro.* Yes, Namur is right, that's the worst. We would really have moved along if only we had taken the proper precautions.

*Toso (bothered).* There you go again with your precautions. I have already told you that the important thing is that we continue to move along.

*Namur (upset).* Let's be precise. Toso is the one who is preventing us from getting to Tar, with his contradictory mind and his refusal to agree with us about how things should be looked at.[12]

In *The Automobile Cemetery,* Lasca and Tiossido also run constantly in circles as they try to break a track record. Fidio and Lilbé in *Orison* always reach the same conclusion that no matter what they do—good or bad—the effect is always an overwhelming ennui.

In her study of *The Condemned Man's Bicycle,* Beverly De Long-Tonelli points out that the circular pattern of Paso's alternating appearances as condemned man and free man is underlined by the acoustical pattern of Viloro's attempted performance of the C scale on the piano.[13] Moreover, this cyclical pattern finds an echo in the repeated appearance of the bicycle, the wheeled cage, the balloons, and the chamber pot, all of which visually support the circularity of the entire mise-en-scène. These visual images of circularity pervade many of Arrabal's plays. Besides *The Condemned Man's Bicycle,* both *Fando and Lis* and *The Grand Ceremonial* contain activities that resolve around a wagon. In *Automobile Graveyard* and *The Tricycle,* the construction of the vehicles unrelievedly supports the circular nature of the children's games. Balloons and chamber pots make their appearance in *Guernica, First Holy Communion,* and *Ceremony for a Murdered Black,* both as part of the child-adult syndrome of those

plays and as symbols of the inexplicable nature of the characters' lives.

As in all games, the objects of play absorb importance from the activity in which they are used; the market value of a football and its value as it is being carried over the goal line cannot be equated. When children are playing a game of marbles, the value they place on the marbles in play, especially the favorite ones, far outstrips their intrinsic value as objects. Similarly, Fando's drum gains value because it is part of his child's fantasy world—and thus is as valuable as Lis's life. Apal's and Climando's tricycle is an essential part of their world; it is their means of passing time, of playing, of having fun. Consequently, they will do anything to keep it even kill the man "with the money." Jerome's and Vincent's costumes have little value as discarded clothing in an attic trunk, but they become the means of their transformation into great actors once these two characters enter their world of illusions and fantasies.

Given the inordinate desire of his characters to escape into their own fantasies and illusions, their persistence in their repetitive games, their attempts at creating a "magic" language, and the sacralization of the objects of their games, it is inevitable that elements of ritual and ceremony should insinuate themselves into their lives and occasionally provide not only a structure for the otherwise chaotic nature of their lives but its very raison d'être. Ritual even more than games tends to be a communal activity, since it is a reenactment of some meaningful past act in the history of the community. It gives value to the existence of the community and to the individuals who participate in it; it is one of the ways man uses to escape from the world of profane time and to recapture the sacred time of his lost paradise. In effect, ritual is an attempt to give metaphysical value to human existence.[14] Drama, of course, has always been concerned with the cosmic in man's life. It has celebrated his victories and given ample display to his faults. There are some critics who insist that the Greek drama was a reflection and outgrowth of the Greek Dionysian and orphic rituals, of the celebration of nature's cycles and the gods' interventions in man's life. Certainly ritual is a sacralization of man's play; it makes holy what is important in life.

The three basic forms of ritual—sacrifice, contest, and perfor-
mance—appear in various combinations and with varying empha-
sis in many of Arrabal's plays. From *Fando and Lis* to *The Architect
and the Emperor of Assyria* we have seen that contest or agonistic
activity is part of the childhood world of his characters. The
shocking crucifixion and death of Emanou in *Automobile Graveyard,*
the gratuitous slaying of Francis of Assisi in *Ceremony for a Murdered
Black,* Cavanosa's nightly sacrifice of a young girl, the Emperor's
execution with a hammer, and the Architect's cannibalistic indul-
gence give sufficient illustration of Arrabal's awareness of the rap-
port between ritual and sacrifice.

It is in *The Architect and the Emperor of Assyria,* however, that the
use of ritual finds its richest and most profound significance, for
besides the cannibalistic sacrifice of the denouement, the games,
the travesty, and trial scenes, the play gradually grows into a
parable of the fall of modern, technological man—of man looking
for another way of being.

Beginning and ending as it does with an airplane crash, the play
not so subtly indicates modern man's dependence upon, and de-
struction by, technology. The frequent transformation of the two
characters who represent alternately their alter egos and distorted
reverse images of themselves and others stands in contradiction to
the basic principle of the identity and integrity of the person that
pervades Western thought. Most important, however, is the con-
flict between a linear and cyclical representation of man's history
that derives from the juxtaposition of these two characters. The
Emperor, as we discover, is the bearer, by happenstance, of all the
knowledge of Western man, including the linear and progressive
view of history:

*Emperor.* What a brute! In a pirogue. In this century of progress, of
   civilization, of flying saucers, to float about in a hollowed-out
   canoe! If Icarus, Leonardo da Vinci, or Einstein raised their
   heads! Why did we invent the helicopter? [15]

Occasionally, though, the Emperor opines that the world is going
to the dogs.

The Architect, on the other hand, maintains almost throughout

the play his intimate contact with nature and nature's cycles, which he is able to control by some mysterious power. Cradled in the rhythmic cycles of nature, he tends to absorb the new into his familiar world of myths and archetypes, which provide him with a comfortable view of the cosmos and man's position within it. His vision of the world, however, is at least profoundly altered if not shattered by the arrival of the Emperor—the new man.

The ritual of this play, then, is more than a mere theater game providing a vehicle for two actors, and more than a tragicomic view of a particular modern man confronting a primitive on a deserted island a la Robinson Crusoe. We are, in effect, presented with a theatrical view of man's return to a periodic and cyclical view of the train of events he calls his history. It is with all of the baggage of his civilization that the Emperor arrives on the scene, and with all the baggage of his own particular past—with God, Freud, his mother, and modern mathematics all thrown together pell-mell.

Traditional man, here represented by the Architect, is introduced to history—at least somewhat—by becoming the Emperor's pupil and by participating in the trial and judgment of the Emperor. It is here that history is transformed into myth and games into ritual. For with the help of the Architect, the Emperor incorporates the events of his past into his mythology, places them outside linear time, and through the ritual at the end of the play attempts to cleanse himself of the "guilt" of the sadistic murder of his mother.

The recapitulation that terminates the action of the play is actually a new beginning of the games with which the Emperor and the Architect amuse themselves and pass the time of day. But here the games are transformed into significant gestures within the cathartic ritual of confession, judgment, forgiveness, death, and resurrection. They seem to signal in a theatrical way the victory of the Architect's cyclical and natural view of himself within a universe based on repetition. The Architect-Emperor confirms this as he intones:

*Architect-Emperor.* This time it's for sure. I'm going to be happy. A
    new life is beginning for me. I'll forget the past. Better yet, I'll

forget the past but only to have it even more present in my mind, so as not to fall into the trap of the same stupid errors. No sentimentality. Not a tear for anyone! . . . What a man! And since I'm all alone, the human race won't envy me, won't persecute me. No one will know the talents of this unique inhabitant of this planet, I mean this deserted island. And so since no one can hear me. . . . Long may I live! Long may I live! Long may I live! And shit on everybody else! Long may I live! Long may I live! [16]

But the rite of passage is not yet ended. A deafening roar signals the arrival of yet another survivor of contemporary technological civilization and the transformation of the Architect-Emperor into a screaming, frightened primitive. Thereafter, we are to assume that the same series of activities takes place: the initiation of the new Architect into the world of "knowledge"; the Emperor's plunge into his childhood memories, his trial, conviction, death, and resurrection.

It is within the context of ritual that the profound ambiguity of the play is explored. Since the characters are not put into contact with the gods through their repetition of paradigmatic gestures, they do not recover the lost paradise of man's wholeness; their gestures are empty of sacred significance. Instead, we witness the breakdown of the person in a whirligig of transformations. In addition, the time of this play, although cyclical, is not sacralized, and so the Emperor and his primitive companion are condemned to repeat their gestures ad infinitum. Under these conditions, as Eliade indicates, cyclical time, rather than consoling and comforting, becomes terrifying.[17]

Moreover, the constant repetition of the same actions, the raking over and over again of the Emperor's past, both real and imagined—the mocking references to Freud, to castrated and crazed political leaders, to a bankrupt popular culture of pinball machines and television, and to the entire plethora of fantasies of our modern culture—points to the decomposition of a culture rather than to its renewal. In effect, the circular structure of the play, with the pseudoritual at its center, portrays all too well modern man's paralysis before the dilemma of Western civilization and his

escape into a past that is comfortable because it is known. The island of Robinson Crusoe, separated as it was from civilization, at least represented an adventure, but here it represents a haven from the adventures of the present and a protective armor from the challenges of the future. The piece, then, is a morality play of lost innocence but not of lost guilt.

But there is a bright side to this tragicomedy. As the Emperor is transformed into the Architect and the Architect into the Emperor—as one plays wife, the other husband; one the teacher, the other the student; one the master, the other the slave—we are conscious of their condemnation to each other, but we are also aware of the joy they experience in having each other. They, like other characters in Arrabal's universe, share their miserable existences as two children share a bag of goodies. The last scenes, within the context of their friendship, becomes a final act of profound kinship—a salutary joining together. Their joy more than outweighs the realization of the tragic impasse that the human condition represents.

The games of Arrabal's characters can be traced to the development of the adult child of his early plays, the role of chance and confusion in his panic theory, and the role of the game per se in the evolution of art in the twentieth century.

Certainly, one of the ways Arrabal used to establish the personality of the adult child was the game. Games, as any observer of human culture is aware, permeate the lives of children and adults alike, and although they are associated principally with children's pastimes, they also constitute an essential part of adult culture. Perhaps more than any other characteristic of the adult child his propensity for game playing helps to bridge the gap of his duality.

In his burlesque panic theory, Arrabal states that chance invades all that is human and that it brings confusion and the unexpected into human life. Chance also intrudes upon the area of the game and brings with it the abritrary and the aleatory, the horrible image of destiny that keeps man balanced between fear and hope. Games of chance, as Caillois points out, are human par excellence, for whereas games of competition are shared by animals, games of chance are not.[18] Moreover, it is the adult who can participate

fully in the game of chance, since objective and calculating reflection and at least the possibility of foreseeing are necessary for the thrill of playing.

Certainly as a member of the avant-garde in the widest acceptance of that slippery metaphor, Arrabal has not been impervious to the intrusion the game has made in the serious realm of art in this century. From Claude Debussy's ballet *Jeux* (1916), which Sergei Diaghilev choreographed as a tennis game, to the various games of the surrealists, the mobiles of Alexander Calder, and the musical pieces of John Cage, the game has come to represent the aleatory and the ambiguous in twentieth-century aesthetics. It is fitting that Arrabal, as a member of the avant-garde, has included the game in his theater, not only as a structuring element for his plays, but as an essential part of the metaphor he has created to represent the human condition.

Likewise, his reliance on ritual ties him to the avant-gardists—to Artaud first of all, and then to the avant-garde playwrights of the 1950s and 1960s such as Beckett, Genet, and Ionesco. As with the game, Arrabal uses the ritual as a structuring framework for some of his plays, notably *The Lay of Barabbas* and *The Architect and the Emperor of Assyria*. Yet the consequences of the use of the ritual in his theater are much more than a mere structuring element in any particular play, since ritual touches a very sensitive nerve in contemporary culture. ·

All the characters of his play, as already observed, live on the edge of real society; they are placed at a distance from us by their living condition, as in *Automobile Graveyard;* by their sexual perversions, as in *The Grand Ceremonial;* by their illusions, as in *The Garden of Earthly Delight;* or by their newfound environment, as in *The Architect and the Emperor of Assyria*. Because of the distance between them and us, they begin to take on a mythical character without becoming the larger-than-life characters of the Greek tragedies; still they are never as real as the fellow next door. As metaphors, they represent the oppressiveness of our civilization just as do the Professor in Ionesco's *The Lesson* or Hamm in Beckett's *Endgame*. Despite the obviously corrosive atmosphere they inhabit, one must remark their singular ability to maintain their joy in life—the simple joy that they exist. This single characteristic, it seems to me,

distinguishes all of Arrabal's characters from Fando to the Emperor from any of the similar mythical characters of the absurdist playwrights. Pariahs they may be, but they remain joyful almost to a man. In a sense, what matters to these characters is not that they have fallen into the profane time of humanity—deformed or not—but that they can occasionally reach for the sacred time of the gods.

## Notes

1. Richard Schechner, "Approaches to Theory/Criticism," *The Drama Review* 10 (1966): 50-51.
2. John Huizinga, *Homo Ludens* (Boston: Beacon Press, 1955), pp. 13-14.
3. Ibid., p. 13.
4. Fernando Arrabal, *Théâtre 2* (Paris: Christian Bourgois, 1968), p. 107. All translations are mine unless otherwise noted.
5. Huizinga, p. 46.
6. Roger Caillois, *Les Jeux et les hommes* (Paris: Editions Gallimard, 1958), pp. 60-1.
7. Ibid., p. 111.
8. Huizinga, p. 11.
9. Fernando Arrabal, *Théâtre 8* (Paris: Christian Bourgois, 1970). Produced at the Alliance Française in Paris in October 1960, the piece was a complete failure, according to Arrabal.
10. Fernando Arrabal, *Théâtre panique* (Paris: Christian Bourgois, 1967).
11. Schechner, pp. 28-29.
12. Fernando Arrabal, *Théâtre 1* (Paris: Christian Bourgois, 1968), p. 86.
13. Beverly J. De Long-Tonelli, "Arrabal's Dramatic Structure," *Modern Drama* 14 (September 1971): 207-8.
14. Mircea Eliade, *The Myth of the Eternal Return*, trans. Willard R. Trask (New York: Pantheon Books, 1954) pp. 20-21.
15. Arrabal, *Théâtre panique*, p. 137.
16. Ibid., pp. 195-97.
17. Mircea Eliade, *The Sacred and the Profane* trans. Willard R. Trask (New York: Harcourt, Brace and World, 1959), p. 107.
18. Caillois, p. 59.

# 4.

# Arrabal's Theater of the Erotic

To the dismay of many critics and theatergoers as well, Arrabal has insisted upon drawing attention to the darker areas of the human condition; to man's erotic fantasies; to deviant sexual behavior; to his own fetishes, dreams, and nightmares. From the oedipal taboo to cunnilingus and fellatio, from voyeurism to bestiality, there is little that does not find its way into Arrabal's plays. Everything is permitted. All barriers seem to have been breached.[1] This singularly shy Spaniard has dared to display, indeed to flaunt that which has been, at least until recent times, relegated to the pornographic filmhouses of our cities' tenderloin districts.

The erotic tends to escape definition because considerable confusion arises between the commonly pornographic and obscene and the genuinely erotic. This confusion is reflected in the works of Arrabal. At times, for instance, in *The Lay of Barabbas* a theatricalized initiation rite into love and panic, Kardo and Malderic jump about making obscene gestures and noises. On the other hand, *Fando and Lis* contains touchingly erotic scenes in which Fando describes how he shares Lis with friends and passers-by. Taken in its widest and most popular sense, the erotic would no

doubt include within its scope both the pornographic and the obscene. Yet its most important aspects go far beyond that which might appeal only to the prurient interests of the spectator or reader. In effect, the erotic touches upon areas of human life that remain obscured among layers of learned social behavior and depends upon the uniquely human ability to reflect upon the sexual act divorced from its natural goal of reproduction.[2] With this ability to internalize the sexual and transform it into the erotic come the concepts of transgression, sin, and guilt. Furthermore, the taboos that surround the performance of making love lead to a ritualization that brings into play some of man's basic religious impulses.

In his earliest plays in which the adult-child character appears, Arrabal most frequently links the erotic with sadomasochistic cruelty and violence. In *Fando and Lis* the two characters are involved in a master-slave relationship that sees them exchange roles in an increasingly sadistic fashion. The instruments of torture—chains and handcuffs—prominently attached to the wagon that is to take them to Tar, eventually become instruments of death. What might have been an amorous affair between these two characters is made erotic by Fando's inability to possess Lis, who is more intelligent than Fando and who is paralyzed. Fando, who is most probably impotent, compensates for his inability to fulfill his love by offering Lis to his friends and then killing her, ostensibly for breaking his drum. We see here the familiar conjunction in Arrabal's work of love and death.

In *Ceremony for a Murdered Black,* Jerome and Vincent kill the black Saint Francis of Assisi after he has made love to their friend Luce. They in turn compensate for their inability to make love with the only woman in their lives by murdering the hapless black who could, and then letting his body rot under the bed. In Arrabal's parody of the Christ story, *Automobile Graveyard,* Emanou tries anxiously to make love to Dila behind the decaying junk but finds his every move observed by the unseen voyeurs who inhabit this marginal world. In the nightmarish *Condemned Man's Bicycle,* Tasla, the young and innocent friend of Viloro, is frequently transformed into a lascivious vamp as she makes love to Paso, the man who is condemned to death. Tasla and Viloro can exchange cham-

ber pots and laugh gaily in their innocence, but they cannot make love as Tasla wants because Viloro, incapable of playing the C scale, is certainly not capable of sexual intercourse. And when he finally is, Paso has him bound and shackled so that he cannot. Like the black Saint Francis of Assisi, he is blithely murdered.

With all of these creatures, some impediment, either physical or psychological, prevents them from performing sexual intercourse. The consequent tension then plays either a primary role in the development of the play, as in *Fando and Lis,* or a secondary one, as in *Automobile Graveyard.* In either case, death and love are linked. The erotic here stems directly from the inability to perform. The desire exists, but the force to overcome whatever sense of shame or guilt does not empower these adult children to transgress some unwritten rule of their own making. Death is a result of the explosion of the energy built up around the forbidden act and the desire to perform it.

The elaboration of his panic theory and theater infused Arrabal's works with a slightly different erotic point of view. His panic plays are not locked into the sadomasochistic circle. They explore necrophilia and orgiastic rituals and pursue the sacrilegious all in the name of love and panic. Arrabal seems to have drawn a sense of freedom from his conversation with his friends with whom he elaborated his theories.

*First Holy Communion,*[3] subtitled *Panic Ceremony,* reveals Arrabal's obsession with both the erotic and the sacrilegious. It constitutes another voyage into his oneiric universe and gives a theatrical insight into Arrabal's world of mad duennas, necrophiles, and petulant young girls. As the play opens, a bier, surrounded by burning candles and a huge iron cross, stands on one side of the stage. On the other stands a table with the various articles of clothing for a young girl who is to receive her first holy communion. Two men enter carrying the nude body of a dead woman, which they place on the bier and then kneel to pray. Suddenly they jump to their feet, remove the body, and leave. Then the necrophile enters in hot pursuit. He is dressed in a manner suiting his propensities and is obviously sexually excited. He sets off after his victim. Meanwhile, a young girl dressed only in her underclothes arrives, followed by her grandmother. The grandmother

dresses her while talking incessantly about the need to maintain a spotless household in order to win and keep a husband. Her chatter is punctuated by the young girl's questions about the necrophile's ever increasing sexual excitement. When the girl is finally dressed in an elaborate wedding gown, the grandmother leaves her to help the necrophile prepare himself for his love feast with the dead woman. The play ends as the young girl stabs the necrophile, now in the coffin, and balloons rise to the heavens.

A satirical view of the old-fashioned idea of women's attachment to home and hearth, an erotico-sacrilegious fantasy, a theatrical experiment in dual focus activity—the play is all of these. Its most important aspect and the one that lends itself to an integrated interpretation of this play deals with the erotic. Arrabal takes the preparation of the young girl for the unbloody sacrifice of the mass and makes it into a preparation for a real sacrifice, the killing of the necrophile. His murder makes her a participant in his act, since she helps him fulfill his basically psychotic wish to be joined with the dead woman's body.

The erotic also puts the grandmother's jabbering about a woman's household duties in perspective. While dressing the girl in a baroque gown suitable for a bride, she speaks of nothing but the need for cleanliness, as if she were preparing the young girl for her marriage, not her first communion. She reveals her true motives: "Today, you're going to receive your first holy communion, you're going to become a real woman. The Lord will come into your heart and take away all stain of sin." [4] The grandmother's combining, in a cause-and-effect relationship, the reception of communion for the first time and the state of genuine womanhood is not merely an accident of language. The participation in the "sacrifice" of the mass and womanhood are joined here by the erotic. In the case of the sacred, the taking of communion, and the profane, the act of truly becoming a woman through sexual intercouse, it is the "flesh" that is revealed: the flesh of Christ combined with her own, and her flesh combined with that of her future husband. Arrabal has most provocatively underscored a much-overlooked relationship in a complex and dark area of human behavior.[5]

The necrophile's intensive pursuit of the dead woman and his joining her in the coffin is an obviously erotic act that evokes as

much horror in a contemporary audience as the juxtaposition of marriage and the eating of the flesh of a victim of sacrifice. Shock is, of course, Arrabal's intended effect. Even though today's blasé audiences, are exposed to the violence of daily life and to endless varieties of pornography, revulsion is still the normal reaction to necrophilia.

There are, however, two elements that color this picture of necrophilia cum sacrilege, both of which deal with the theatricality of this piece. The necrophile's clothing, his ever growing sex organ— like a snake at the conclusion of the play—and his wild chase of the two men bearing the woman's body all add a zany Keystone Cops aura to this play that stands in contrast to the horror evoked by the theme of necrophilia. At its conclusion, after the girl stabs the necrophile and is splattered with blood, two red balloons float off toward the moon. The same effect was used in *The Condemned Man's Bicycle* to indicate that the characters found the freedom they hoped for. I would suggest that the necrophile has indeed found freedom from his obsessions and society's condemnation of them in the play but that his clothing, his actions, and the balloons add a comic luster to this play that is inappropriate to the themes treated. The comic and theatrical aspects of the play permit the audience to achieve a distance between what it is viewing and what it is feeling, so that the full impact of the erotic is considerably softened. The result is an ambiguous stance toward the play's principal concerns.

*Impossible Loves,*[6] a companion piece to *First Holy Communion,* suffers from the same ambiguity caused by a combination of theatrical and comic effects. To the strains of Fréderic Chopin, a soprano sings to us of a lonely princess in a far-off land who is looking for a pure love that would redeem her, a total love to which she could devote her entire life. The Princess, however, is in love with a Prince with a dog's head and is sexually attracted to another Prince with a bull's head whom she openly pets and caresses lasciviously. The Princess greets her dog-headed lover in a romantic, high-blown manner: "But what is this spectacle that offers itself to my regard? Could it be a dream, an illusion? O God, cease to torment me thus! What is it that I see?" [7] The two Princes enter into mortal combat. The dog-Prince is killed and the bull-

Prince commits suicide. The Princess, beside herself with grief, takes her life. The Princess' father, a fellow with an elephant's head, enters and obscenely caresses his daughter's thighs. One can conclude from this that the playwright means that all men are animals but that women, who love the animality of men, are not. The playlet is an amusing spectacle, a fairy tale gone wild in which the erotic behavior of the characters contrasts sharply with their noble but artificial language. Nevertheless, it lacks real substance.

Still within the framework of the erotic and panic lies one of Arrabal's operas, *Ars Amandi*.[8] Like *The Garden of Earthly Delights*, it explores the theme of love within a panic ritual, and like the *Lay of Barabbas* it is structured around a series of games. In it we see the return of Lys, as a great earth mother figure leading the hero, Fridigan, to love and fulfillment. To be sure, it is unlike any traditional opera. In opera, normally no justification is given for the singing and the music; they are an accepted aspect of the art form. But Arrabal cleverly works out a justification for it here. Bana and Ang, two domestics who participate as subordinates in the ritual, cannot talk without stuttering, but they have no difficulty singing. So the other character, Lys and Fridigan, decide to sing along with them to avoid embarrassing them.

As the curtain rises on the piece, a huge image of Lys is projected on a screen at the back of the stage. A swarming mass of bees or ants seems to be attacking her. In the next scene, a normal-sized Lys invites Fridigan to stay with her in her "laboratory," where with the help of her two assistants she induces Fridigan to fall in love with her; to make love with her in a pigsty; and finally to admit to an injection of sorts, whereupon he becomes one of the bees or ants, who are really lovers, swarming about her body.

Fridigan, like Giafar in *The Lay of Barabbas,* stumbles into Lys's residence by accident. He happens to be in the region in search of his friend, Erasmus Marx, who mysteriously disappeared a few days earlier. We learn nothing of Erasmus Marx during the play, but his name or his initials appear on silverware and table napkins and on miniature buses, hearses, and helicopters, which convinces Fridigan that he is on the right trail in pursuit of his lost friend.

Fridigan is ignorant of the ways of love; as his name indicates, he is frigid. Lys, however, will initiate him into love, and then

permit him, along with many others, to prey upon her in a continual act of love. Erasmus, we may assume, fell prey to Lys's trap immediately before Fridigan; he, like Fridigan, was ignorant of love. Perhaps, as were his namesakes, he is more interested in cerebral pursuits. If not completely ignorant of love, the pair is certainly ignorant of the type of erotic love that Lys shows them.

Bana and Ang are Lys's two laboratory assistants. They play roles similar to those of Kardo and Malderic in *The Lay of Barabbas:* they prepare the unsuspecting Fridigan for his love feast with Lys. These two are neither children nor adults; they are somewhat reminiscent of the characters of Arrabal's earliest plays, for they are adults but continue to play children's games. Their main role is to be assistants in this ritual, and it is not by coincidence that a combination of their names gives the vulgar American term for sexual intercourse, "bang."

To these characters can be added a host of others both historical and mythical: Frankenstein, Dracula, Christ, King Kong, Don Quixote, Tom Thumb, Romeo, Pinocchio, Othello, Tarzan and Jane, and Mary Magdalene. At the beginning of the play they appear as mannequins, as figures from the back lot of a Hollywood movie set; but they become more and more involved in the action, so that by the final scene they are an integral part of the initiation rite. When Fridigan and Lys make love, they play out a series of mini-dramas that belong to the real or imagined history of one of the group. For example, Romeo helps Tarzan with his cross while King Kong plays the role of Mary Magdalene. In the stage directions Arrabal insists that these scenes be played with precision, since they are of capital importance in the initiation of Fridigan into panic love.[9]

The various characters represent the panic world, which is, at the beginning of the play, unknown to Fridigan. By entering into their universe, he will permit them to communicate with him, as Bana tells him very early in this new experience. At first he tries to speak to the mannequins and even calls them all by name, but to no avail. Then he begins to dance with great enthusiasm, still to no avail. But a pratfall brings forth a loud guffaw from Frankenstein. Fridigan has taken his first step into their world. A series of slide

projections, ranging from a photograph of a fireman from La Belle Epoque to a detail from Bosch's *Garden of Earthly Delights,* signals Fridigan's first entry into the world of panic.

This panic world, as we have seen in previous plays, is one of illusion, of pure theatricality, and of baroque transformation. It is a world that Arrabal insists is realistic—but realistic including the nightmare.[10] It is a childhood world of joy and tenderness but one that can abruptly become grotesque and horrible. Bana and Ang, whose paranoia helps create the atmosphere for many of the abrupt changes, demonstrate that the panic world is always on the point of exploding when they recount their mutually complementary nightmares:

*Bana.* I dreamed that I became very tiny like a little beetle and that I snuggled up in the palm of your hand. And you petted me, but then you put another animal next to me that looked like a snail that was going to eat me up. *(He is on the verge of tears.)* But I love you anyway.
*Lys. (to Ang).* And what did you dream?
*Ang.* It was very different.
*Lys.* Tell me.
*Ang.* I dreamed that I saw you bathed in light and I was changed into a tiny snail. You kept me in the palm of your hand and you petted me, but then you picked up a beetle that looked like it was going to eat me up.[11]

The juxtaposition of the grotesque and the tender as in these two nightmares is carried through on the level of the action of the play. Ugly cruelty is transformed suddenly into a loving tenderness and vice versa. Lys whips Ang and Bana, then puts ointment on their wounds; she chains their neck and their feet so that the chains dig into their backs, but the wounds disappear. It is all a grotesque illusion designed to disorient Fridigan in preparation for his love feast. Such is Arrabal's panic universe. Whatever happens can be easily contradicted, and whatever is said soon loses its meaning; there is no cause-and-effect relationship between the various activities; there is no logic. In fact, one of the principal activities of

the play, the search for Erasmus Marx, becomes an illusion, a part of the pure theatricality of this strange world.

The constant stress upon the illusory derives, in part, from Arrabal's efforts to include in this theater as much confusion as possible, a hallmark of his Panic Theater. "The idea of 'confusion' is an obsession with me," he says. "I understand by confusion everything that is contradictory, inexplicable, unforeseen, everything that makes '*coups de théâtre*,' and I believe that everything that is human today, everything that is part of our earthly existence is confused. I am creating a realist theater that represents that confusion." [12]

Much of what Arrabal calls confusion deals with the erotic, since in many plays the erotic tends to interfere with the normal flow of the action and frequently abruptly changes the tone and the pacing of a scene. In this play, the initiation of Fridigan to erotic love *is* the action of the play, and most of the activities of Bana and Ang are related to it; but the wild dancing and orgiastic reveling are punctuated by an important erotic ceremony that marks various steps in Fridigan's progress. During the ceremony Ang and Bana cover Lys's shoulders with a cape, they embrace her, lasciviously kiss her feet, and then, while holding her long cape outstretched, they walk in procession behind a transparent screen. There the two servants undress Lys with great ceremony; Ang climbs on her shoulders; and Bana, on his knees, lightly kisses her on the abdomen. Accompanied by the singing and the miming of the mannequins, the scene takes on a ludicrously solemn air. Nevertheless, it marks very definite points in Fridigan's initiation: first his entrance into the world of panic; second, his total confusion; and third, his complete participation in the ritual as he plays judge and condemns Lys to death.

The final scene in which Lys and Fridigan make love in a pigsty makes him a master in the art of loving; it also points once more Arrabal's tendency to make love a dirty and violent act—a tendency expressed in many ways since his earliest plays. In an interview with Françoise Espinasse, he explores the reason for this position when Espinasse asked him if he is in favor of a violent and dirty act of love:

—Yes, it has to be dirty. Anyway, somewhere in there I have been trying to discover certain moments of my childhood. When the Spanish police provoked me, I said, "Shit on God." Something from my childhood experience comes into my mind. I must have done something with my excrement, and either my father or my mother slapped me. Maybe my entire physical behavior was conditioned at that point.[13]

What Arrabal is searching for in his subconscious reveals itself in the juxtaposition of what is dirty and forbidden with the act of love in his plays. He intensifies the erotic aspect of the experience by making it a transgression, a breaking of a taboo. It is this primitive notion that he underlines with such force by the love scene in the pigsty. Moreover, he touches on a universal feeling in our civilization by doing so, for the contiguity of the reproductive organs and the urinary and anal tracts in man has contributed to the idea that his sexual organs are shameful and that the sexual act is dirty. This idea is, perhaps, no better expressed than in the dictum of Saint Augustine: "Inter faeces et urinam nascimur." Eroticism is at once horrible and desirable, beautiful and ugly, capable of bringing forth great creative power in man as well as destructive urges. It is unpredictable and fascinating. It is evil—but very human.

Paradoxically, it is the very idea of evil and shame that Fridigan must overcome in order to enter into the special world of peace and contentment as a lover *in perpetuum* of Lys, the earth mother of the panic world. This he does by receiving an injection. Such a deus ex machina, although not unusual in Arrabal's world of fantasy and illusion, unfortunately tells us little about the human condition, about giving and receiving love, about our sexuality and our erotic desires. Instead, we are treated to the circus of a panic ritual that seems curiously out of touch with the topics Arrabal is investigating. The piece is out of joint. It is one thing to bring Fridigan to the trough of erotic love; it is another to make him lie down in pig dung. Arrabal, it seems, is as uncomfortable with the theme of erotica as is his audience. The result is that he confuses the scatological and the sexually erotic; he frequently shocks his

audience rather than moving it to explore its own thoughts and feelings. Shock, however, cannot replace insight.

Like most of the major panic works, this text calls for a plethora of games and activities, accompanied by secondary effects of bizarre lighting, film clips, and slides. Added to this formula here are the music and songs of an opera. From a technical point of view, the challenge of staging such an operatic spectacle is obvious, but from a purely theatrical point of view the effect is supposed to be the creation of a fabulous world of fantasy both frightening and wonderful—a whirligig of disconnected activities as amazing to the spectator as to Fridigan, the unwitting victim of this panic ceremony. The primary effect is the creation of an illusion that serves as part of Fridigan's initiation into the panic world and his preparation as one of Lys's many lovers.

It is indicative of Arrabal's wide-ranging interest in the theater that he should attempt an operatic libretto, since opera is a singularly tradition-bound medium and Arrabal's vision, even in its more conservative moments, is antitraditional. On the other hand, the opera lends itself readily to the creation of the illusion, and Arrabal is no doubt aware of that quality. Yet it would serve his purposes better if he would use more sparingly theatricality for its own sake, which tends to diminish the tensions needed for genuine drama.

*Erotic Bestiality,* a playlet written shortly after the completion of *Ars Amandi,* emphasizes with a strident voice the need to immerse onself in the crudest sort of erotic behavior in order to attain a pure and satisfying love. The piece is divided into two parts. In the first part, Asan and Alima dismount from their two beautiful human "horses" and begin to declare their love for each other while their beautiful "mounts" make passionate love in the background. As the two horses become more and more sexually excited, Alima's and Asan's flattering comments turn perversely gross.

*Asan.* We were born for each other.
*Alima.* But I am not perfect.
*Asan.* Why?
*Alima.* Because . . . I smell nice.

*Asan.* You smell . . . you smell like you're having your period.
*Alima (shamefully).* Do I make you sick?
*Asan.* You stink to high heaven!! [14]

The pair then sexually excite their two "horses," which fall to the
ground and lick the soles of their feet. As the scene ends, the two
horses are whisked off in a boat, leaving the two lovers asleep
enveloped in a huge embryolike veil.

In the second scene, Asan and Alima, like Adam and Eve before
the Fall, live in peace and contentment. They are free and happy.
The horses' skeletons hang in the distance. Here Arrabal tries to
assert the primacy of pure love, free from the vagaries of arbitrary
language and social norms, but his parody is much too superficial
and his humor too black. Moreover, he gives no justification for his
thesis that immersion in perverse sexuality somehow sets one free.
The theatrical metaphor does not function even on the scatological
level, and we do not even have the entertainment of a panic circus
to divert us, as in *Ars Amandi.*

To be fair to Arrabal, these two plays, *Ars Amandi* and *Erotic
Bestiality,* remain personal statements about his own development.
They constitute a rite of exorcism of his own obsessions and fan-
tasies, both erotic and pornographic, and in many ways prepare
the ground for plays in which his ideas and themes find a more
suitable theatrical expression. Arrabal readily admits that his ero-
tic plays "form a part of [his] work which is the most spontaneous,
the most deeply felt, the part in which [his] thoughts, intelligence,
and reason played a very small rôle." [15] But when the erotic is
joined to other themes, used to put into relief other problems, its
true value in Arrabal's theater becomes apparent.

In *The Architect and the Emperor of Assyria,* the erotic invades the
fantasies of the Emperor, which the two characters act out either
alone or together on their desert island. At the end of the second
scene the Emperor, abandoned by the Architect, dresses up like a
woman while recounting how he almost proved the existence of
God on a pinball machine. His dressing is an obvious part of a
long-held fantasy as he displays the various pieces of women's
underwear that he is donning and he caresses his legs and thighs.

Likewise, in the last act, we traverse the life of the Emperor, especially those moments that led up to the murder of his mother to whom he was inordinately attached. His brother tells of the emperor's sexual peccadilloes with his young schoolmates and how he himself was perverted by his brother's early sexual desires. And the Emperor, when he still imagines himself in the position of Emperor, grandiloquently describes how he was awakened each morning:

> *Emperor.* . . . Ten thousand amazons, whom my father brought directly from the East Indies, scurried nude each morning into my apartment and kissed the tips of my fingers while intoning the Imperial anthem.[16]

The truly erotic aura that surrounds this play derives from the conjunction of the sacrifice of the Emperor and the eating of the flesh of the victim. This anthropophagy breaks down all the barriers between the Emperor and the Architect, since the latter ingests the memory, the emotions, and the psyche of the Emperor along with his body. Not only does the dialectic of transgression and interdict Bataille places at the very foundation of the erotic act comes into play here, so does the idea of total and complete immersion in the other, the idea of the death that gives life.[17]

In *and they put handcuffs on the flowers,* a play devoted to the lives of four Spanish political prisoners, the erotic grows out of the fundamental theme of oppression—political, social, religious, or sexual. The erotic nightmares of the prisoners demonstrate clearly that their imprisonment is not merely physical, for it leaves them prey to their own obsessions. Characteristically, the erotic dreams also provide us with the one glimmer of freedom in their otherwise stifled lives. Here again, the erotic increases the tension of the dramatic situation.

When Arrabal revels in the obscenely or grossly pornographic when his gothic imagination unleashes scenes such as we see in *Erotic Bestiality* and in *Impossible Loves,* the vision he presents is blurred, he seems to take refuge in the shock effect of these grotesqueries and consequently diminishes the tension of his sometimes searing dramas and diverts the attention of his audience.

Such a fault we might forgive in a young Arrabal, but he is no longer an apprentice. On the other hand, when Arrabal creates truly dramatic situations that grow out of genuine eroticism, it is the erotic that tends to heighten the passions, puts the subject at hand into relief, and affects our deepest emotions.

## Notes

1.  Margaret Croyden, "Here Nothing Is Forbidden," *New York Times,* Sunday, August 9, 1971, sect. 2, pp. 1 and 3.
2.  Georges Bataille, *L'Erotisme* (Paris: Union générale d'éditions, 1957), pp. 33-34.
3.  Fernando Arrabal, *Théâtre panique* (Paris: Christian Bourgois, 1967).
4.  Ibid., p. 26. All translations are mine unless otherwise noted.
5.  Bataille, p. 101.
6.  *Théâtre panique,* pp. 28-39.
7.  Ibid., p. 35.
8.  Fernando Arrabal, *Théâtre 8* (Paris: Christian Bourgois, 1970).
9.  Ibid., p. 79.
10. Alain Schifres, *"Arrabal: le théâtre panique," Réalités* 252 (January 1967): 57.
11. Arrabal, *Théâtre 8,* p. 29.
12. Schifres, p. 57.
13. Françoise Espinasse, "Entretien avec Arrabal," in Fernando Arrabal, *Théâtre 3* (Paris: Christian Bourgois, 1969), p. 18.
14. Fernando Arrabal, *Théâtre 6* (Paris: Christian Bourgois, 1969), p. 138.
15. Alain Schifres, *Entretiens avec Arrabal* (Paris: Pierre Belfond, 1969), p. 75.
16. Arrabal, *Théâtre panique,* p. 167.
17. Bataille, p. 101.

# 5.

# Guerrilla Theater

In the mid-1960s when the campus of every major university was rife with antiwar activity, a new style of theatrical event, dubbed Guerrilla Theater, came into being. The name of this type theater was suggested by Peter Berg, author and member of the San Francisco Mime Troupe.[1] No antiwar gathering at the time was without its street theater or its mime troupe acting out the struggle of Vietnamese peasants against the American invaders or illustrating in some way the death and destruction the Vietnam War was bringing to that country. This was the beginning of a new, committed theater that did not mask its didactic purpose, its intent to change the status quo, and its proposal of a peace-loving, non-repressive society. This was political theater. It was also theater based on a community of engagés artists who thought or felt that their work could have an ameliorative effect on society. Teatro Campesino, which worked with the Chicano farmworkers in southern California, was one such group. The Bread and Puppet Theatre in New York City, with some variations on the theme, also was a Guerrilla Theater troupe.

It did not take long for this concept to cross the Atlantic and

take root there. Street theater is no new form of art for the denizens of the well-known Left Bank in Paris where small groups of actors have plied their trade for centuries; but the strong, abrasive, political tone of Guerrilla Theater provided a new facet to this old form. Ironically, it was an American troupe, The Living Theatre, in exile in Europe, that helped prepare the ground for this type of theater.[2] The Living Theatre's participation in the various Festivals of Free Expression in Paris starting in 1964 and its extraordinary productions, which by the sheer force of their own energy spilled into the streets in the form of impromptu happenings, established this troupe as a guiding force in the new theater. Jodorowsky, Lavelli, Victor García, Topor, and Arrabal, who constituted the marginal theater in Paris from 1964 to 1966 also participated in the Festivals.

For Arrabal, however, the decisive moment in his commitment to a social and political theater was to be his arrest and imprisonment in Spain in July 1967. While on vacation in Madrid, Arrabal inscribed a copy of his book, *Feasts and Rites of Confusion*, with the following dedication: "Me cago en Dios, en la patria y en todo lo demás" ("I shit on God, on the fatherland, and on everything else.")[3] That night he was arrested and placed in solitary confinement. His incarceration brought on an attack of tuberculosis, and he was eventually transferred to a hospital. His imprisonment, much to the surprise of the Spanish officials, caused an international uproar. The Pen Club and the Society of French Authors, including François Mauriac, Jean Anouilh, Samuel Beckett, and Eugène Ionesco, called for his release. Some Spanish newspapers demanded that he be castrated for his insults to the fatherland.

Arrabal's trial took place in September. It was a worthy monument to the founder of the panic movement since his defense consisted of serious evidence mixed with wordplay reminiscent of his musings on the panic man. He confessed that he mistakenly wrote "patria" (country) referring to his cat, "Patra," and that "Dios" referred to the god Pan. He also admitted in a more serious vein that he had taken some pills and several alcoholic drinks before appearing in the department store for the book signing. The court ruled that he was suffering from temporary mental derangement, and he was released with a fine for irresponsible behavior.

The next month he published an article in *Le Monde* in which he describes his imprisonment and the young men he met there, all condemned to excessive prison sentences either for political reasons or for imprudent statements about the state. Arrabal, whose father had been arrested by the Falangists, was already conscious of the repressive nature of the Franco government, but here in face-to-face confrontation with young men who were rotting in dank cells, his own case seemed so petty:

> My own case offers little of interest in comparison with those I've just described. I think I have received exceptionally "favorable" treatment; even so, I can point out certain irregularities of which I was a victim, but which, I am told, take place rather frequently: I was arrested at one o'clock in the morning without any warrant either from the executive or judicial powers; I was placed in solitary for five days, instead of 72 hours, as the law requires (any prisoner put into solitary is not permitted to read or write, does not have the right to a daily walk, and must live and sleep in an underground hole that is constantly lit by an electric bulb).
>
> I was acquitted without any doubt whatsoever because of international pressure. Without support from the outside, I would have remained in prison for a long time like the journalist from the Canaries or the young torero.
>
> I do not belong to anyone or to anything. I only hope that liberty should reign everywhere and that injustice should not oppress others. I would like to believe that everything I have put forth here is false, that I am mistaken, that what I saw and read this summer, in Spain, is only a nightmare.[4]

The prison experience no doubt brought forth memories of his father's imprisonment in Spanish jails in the 1930s and left its impact on whatever he was writing at the time. Even *The Garden of Earthly Delights,* which explored his sexual fantasies and taboos, saw the intrusion of an inquisitional tone that tended to upset the games of illusion. The real impact of his imbroglio with the Franco government, however, makes its appearance in *and they put the handcuffs on the flowers.*

When the events of May 1968 took place, Arrabal manned the barricades with the students and occupied the College of Spain. He said: "There were two truly intense moments in my life, my visit to Cuba in 1960 and the barricades." [5] His participation in the revolt prompted him to write a series of guerrilla playlets entitled *Dawn: Red and Black*.

From his earliest plays Arrabal has always demonstrated a willingness to make a political statement in his theater. His first play, *Picnic on the Battlefield* (1952), gives us his satirical view of war; *The Two Executioners* (1956) is an autobiographical statement depicting the strife resulting from a wife's denunciation of her husband to Fascist authorities; and *Guernica* (1958) shows the horrible results of the firebombing of that tiny Basque town. The thrust of these plays, however, is not to serve as a goad to action or as a didactic instrument that would direct action toward change in society. In effect, one might say that in these early plays the author was not truly engagé, that he was still preoccupied with his oneiric world even though reality occasionally impinged upon it. His imprisonment in Spain and the student uprisings bring him into the fray.

*Groupuscule of My Heart,* the first playlet in *Dawn: Red and Black,* juxtaposes two activities.[6] A woman turns a wheel-like device from its interior while a man in uniform whips her from time to time and a nude couple makes love in a wheelbarrow. These activities are counterbalanced by the formation of a "groupuscule"—a politically active cell—whose members are placed among the spectators and are indistinguishable from them. Counted among the members of this groupuscule are an Orator, an enraged student, and several spectators.

The playlet is divided into seven scenes. Four mime scenes deal with the nude couple, the woman in the wheel, and the man in uniform; the other three concern the formation of the political groupuscule. The mime scenes begin by an exposition of the situation. They comment on the sexual nature of repression and on the role of the artist in a police state; and they end with the death of the oppressor, the man in uniform, and the consequent freedom of the young couple and the woman. In the three spoken scenes, the groupuscule recounts its formation in response to the repression by

university authorities, its solidarity with other movements that desire to overthrow the structures of oppression, and finally its decision to distribute the money hanging in sacks above the playing area.

Ideally, the playing space is supposed to be set up in the street, where gigantic photographs depicting the struggle of the student revolution delineate the playing space. If the action takes place in the theater, the photographs are to be placed on the walls, but the playing space again is preferably to be in the center of the spectators.

The effect intended by the theater in the round, by the photos, and by placing the actors among the spectators is to impart an air of spontaneity and immediacy. Such is the atmosphere that must be produced if Guerrilla Theater is to create its desired effect of directing some type of social or political change. However, spontaneity in Arrabal's theater is always a well-regulated affair. Even in the most delirious moments of a panic festival, all the activities of the participants are clearly stated. This series of scenes is no exception.

The immediacy and spontaneity of the action is emphasized even more by playing as if the group of people present—that is, the audience—is actually the groupuscule of the title. The Orator at the very beginning of the play reveals that the meeting is to take place as a play in order to deceive the authorities into believing it is all a capitalistic venture:

*Orator.* This meeting, in the guise of a play, or if you prefer of street theater, has received proper authorization. The exploiters give us permission to promulgate our revolutionary ideas through books and plays as long as they profit from them. In order to attend a meeting or spectacle such as this, you have to pay, even if they figure that with the proceeds we are going to make bombs or write tracts, since *they* believe that Revolution is impossible. It's up to you to open their eyes! *(long pause).* This meeting, then, has as its goal to prolong our discussion and perhaps the very existence of our movement. Everything depends on all of us. . . .[7]

Arrabal, however, is ambiguous in his attitude toward the groupuscule. Its members are more concerned with words than actions, with the past rather than the future, with panic festivals rather than revolution. Of course, bloody revolution is not what Arrabal intends to promote here. Freedom is the password, and his characters make a call for it even though their shouts are lost in the aphorisms of the real student uprising of May 1968: "exams = repression = servility = social selectivity = society of classes . . . creativity, spontaneity, life . . . exaggerate; that's our weapon." [8] In fact, Arrabal seems to be calling for a society based on panic theory: "I propose," says the enraged student, "that we all have a celebration with the proceeds, and that act will be the most beautiful example that the Revolution could possibly give. We'll unbutton our brains as often as our fly." [9]

Arrabal passes from the black flag of anarchy to the red flag of revolution though in the mime scenes of this playlet. In these scenes the *act* is the only possibility; words are not possible, and because of the situation, real communication is not possible. The oppression exercised by the man in uniform eventually leads to his death. In the stage directions, Arrabal indicated that the policeman should look Mexican—a reference to the Fascist government in power there at the beginning of the century.

The major weakness of the play—indeed the weakness of all Guerrilla Theater—occurs when it dwells on a specific incident, for this very fact tends to date the play, to bind it to the moment in history, and frequently prevents it from making any universal statement. Thus, the scenes portraying the formation of the political groupuscule have no force today and are as ephemeral as the slogans scattered throughout them; the mime scenes, however, deal with oppression more universally and make their point, if rather simplistically.

*All the Perfumes of Arabia* is set in Spain. All its references are aimed at the political situation under the Franco regime, and especially the collusion that sprung up between the political authorities, the church, the business world, and the military to the detriment of the populace.

The playlet concerns more specifically the attempts of a woman

to obtain a stay of execution for her husband, who has been convicted of revolutionary activities. To this end, Maida, the wife of Ybar, calls three different personalities: the Confessor of the Caudillo, a General of the army, and a Banker. We learn in the last scene of the piece that her attempts were in vain, for the chief of state, fearful of intervention on the part of the pope and of foreign powers, ordered the execution to take place one hour earlier than planned. Interspersed with these scenes are two vignettes in which Ybar presents his reasons for returning to Spain, and Maida's laments in which she describes the solitude of her life without him.

Arrabal indicates that the play can be presented either in the theater or in the street. The secondary production elements are therefore kept to a minimum in contrast to the plays of the Panic Theater. Nevertheless, the script calls for two props: the three Spanish officials are to receive their telephone calls standing next to a bowl into which blood is dripping; and Maida makes her calls standing in front of a large pendulum clock. In the first case, the complicity of the three characters in the death of Ybar is made clear, as, of course, is Maida's race against the clock in the second.

The three Spanish officials are painted with large brushstrokes, and as such they seem more like caricatures than characters. This is the effect intended by Arrabal, since he is attacking the puppets of the regime. Moreover, he juxtaposes the generally accepted notions about the Franco government with platitudes muttered by these three men and thereby comments on the conditions in his home country in a bitterly ironic fashion.

The mitered Confessor to the Caudillo speaks to Maida in the most unctuously clerical terms and thus reveals his complicity with the regime:

*Confessor.* My daughter, we all here have your husband present in our minds, and we are all praying for him.
*Maida.* It's a matter of obtaining a stay of execution, so they don't kill him.
*Confessor.* God, in his infinite mercy, can pardon even those who have grievously sinned.
*Maida.* My husband is . . .

*Confessor (interrupting her).* Yes, yes, my daughter, I know all that. You ignore the fact that I spent the Civil War in an embassy, and I know perfectly well what atrocities were committed: convents burned, for example. May God pardon them, my daughter.[11]

The General presents himself as a caballero, a modern Christian and Spanish knight. He makes a special brief for the fatherland, moral integrity, and law and order—all sacred and eternal in his mind.

The Banker disputes the then current notions that Spain is antidemocratic, anti-intellectual, and antihumanistic. He attacks those who would believe that Spain is a backward country not yet ready to make its way into the twentieth century. His defense of Spain is ludicrous, especially his defense of the legal system, which according to him places more emphasis on the swift disposition of a case than on the juridical knowledge of judges and advocates:

*Banker.* . . . But the military courts are also just. And to a certain extent, I would say even more just than the others, since everything is in the hands of the army, which has always saved the fatherland. That's why, instead of admitting a demagogic lawyer who uses his time in court to attack the fatherland, the military court chooses a man who is faithful to the Caudillo and who will defend the accused. In this way, the accused is supported by a man who, although lacking in juridical practice, nevertheless knows how to speak the language of the judge.[12]

By painting these characters so large, by giving them arguments that are either self-aggrandizing or uselessly logical, Arrabal effectively satirizes the three major areas that held, at least in his eyes and the eyes of the general public, the reigns of power and authority in Spain under Franco. The title, taken from the words of the guilt-ridden Lady Macbeth, reflects Arrabal's feelings concerning the responsibility these three share for the death of the innocent Ybar.

The conflict between the forces of order and the forces of liberty is accentuated even more by Maida's futile race against the clock. Theatrically, the suspense is heightened by the struggle, not only with men who are implacable, but with time, which cannot be stopped. The coup de grâce occurs when we learn in a flashback that Ybar was actually killed before the action of the play began.

In *Under the Pavement, the Beach,* Arrabal returns to the student revolution in Paris.[13] He once again presents a dual theatrical vision of those events and their significance. While a tambourine player, dressed in a gothic costume, relates the various stages of the battle between the students and the police, voices from the crowd cry out the slogans of the now famous uprising. As a counterpoint to these scenes, two women, dressed in costumes dating from La Belle Epoque, drag an unconscious young man into the playing area, tie him to a chair, put a dunce cap on his head, jab him with a knife to bring him to consciousness, and dance around him lasciviously.

The first series of activities creates the impression that the spectators are themselves a part of a group of students in revolt, as the cries and slogans come from their midst as well as from around them. Spotlights flash on them, and a group of actors scattered among them sings revolutionary chants. The tambourine player controls this part of the action; a tap on his instrument brings silence, and his announcements describe the battle taking place between students and police.

As in *Groupuscule of My Heart,* Arrabal is trying to create an air of immediacy, but the action remains well regulated. The tambourine player acts as master of ceremonies and elicits from the actor-spectators many of the clichés of the student revolution:

*A Voice.* In the dens of the forces of order, we will make our bombs.
*A Voice.* Long live the Holy War against the State.
*A Voice.* Long live the prerevolutionary reactor.
*A Voice.* It's forbidden to forbid.[14]

These cries, accented by the floodlights, the singing, and the slide projections of scenes of the student battles with police build to a stormy pitch—but a tap on the tambourine brings silence.

The activities of the two women—their binding and jabbing of the young man and their blinding him with a dunce cap to make him look like a fool—represent the stultifying force of a society guided by values and ideas of another age; their lascivious dancing and repeated attempts to assault him sexually emphasize the rapport that exists between repression and sexuality that Arrabal inserts in so many of his plays.

*The Little Cages,* the last playlet in this group, takes place in a totalitarian country, presumably Spain.[15] The tambourine player starts the action with the simple declaration: "They're throwing foreigners into jail." All the prisoners, who can neither understand each other nor be understood by the police are in little cages suspended at various levels from the ceiling if the play is to take place in the theater, or from balconies if in the street. Because all the prisoners speak different languages, a Babel-like atmosphere, accentuated by their attempts to sing together, prevails. The only song they succeed in performing together is the *Internationale,* but a guard, who whips them mercilessly, reduces them to silence.

During one of the periods of silence, we enter into the sexually oneiric world of the Greek prisoner, Karin. During these scenes Karin comes out of his cage, and we see him meet his lover, Lia. In a courtship ritual, he wears a mask or hood representing a lion's head and dons a lion's tail. During this short scene he also plays a bull and a horse. Before they make love, Karin breaks an egg on Lia's head, and she reciprocates. The scene ends with a frenetic dance by Lia.

In the final scene of the play, Greek authorities carry Karin off to his home country. Lia, who has come to visit him, is thrown to the ground, but not before she is able to wipe his face with a cloth, on which his features are imprinted. Arrabal's baroque taste for exaggeration unfortunately sets his meaning askew; whereas many revolutionaries are victims, they are not all Christ figures.

Arrabal's experimentation with this type of theater is not completely unsuccessful. It permits him to attempt the use of various theatrical environments and to take a different stance toward the audience. Furthermore, it provides him with the opportunity to constitute a working model drawn from materials and techniques that formed a major part of his Panic Theater. This model he will

try to perfect in his major guerrilla play, *and they put handcuffs on the flowers.*[16]

Unlike the plays that precede it, this play cannot take place in the street. Indeed, it is of great importance that it take place in a theater of a certain size with various rooms at the disposal of the troupe, because the play actually begins before the actors enter the playing area proper. The script calls for a darkened room between the lobby and the theater, where the members of the audience are to be led one by one before one of the actors or actresses shows them to their places. The master of ceremonies, who is in charge of this darkened room, is to seize each spectator by the arm and whisper into his ear phrases such as: "A man will be killed tonight" or "Alone you enter the penitentiary" or "Remember, thou art dust and unto dust thou shalt return." Meanwhile, from the playing area come the sounds of a woman crying, strange human mutterings, and music of the Pygmies. Incense fills the air. As the spectators are taken to their places in the theater, divided into various levels by scaffolding, the actors take their places among them so that no actor-spectator opposition is established.

Arrabal is attempting to create a certain environment in the theater as he did in *Dawn: Red and Black* in order to emphasize the reality of his prison scene. Just as in the scenes concerning the student revolt, he surrounded the audience with actors or placed his actors among the spectators in order to make it appear that a scene from the revolt was really happening, here he tries to simulate some of the conditions of a prison.

In one of the New York productions of this play (October-November 1971), directed by Arrabal, the curtain time was delayed by one-half hour.[17] Since the lobby was extremely small, the eighty to one hundred persons were crowded uncomfortably into a small space for what seemed an inordinately long time. The audience thus experienced in a very inexact but still convincing manner what it means to be crowded into a small space with a considerable number of other people—a fact of life in Spanish prisons.

The preperformance activities proposed by the playwright can cause various reactions among members of the audience, who, unlike the actors, are not rehearsed. Since the audience brings to

the theater an entire repertory of learned responses, its reactions to this different theatrical experience are difficult to foresee. Thus, Arrabal indicates that the actors must be attuned to the audience and must choose the conduct most fitting for them. In Guerrilla Theater, the response of the audience takes on extreme importance, for the desired effect is not simply empathy but also involvement and possible mobilization.

Fully realizing that audience reaction can be difficult to control and predict, Arrabal has placed a scene in the middle of the play in which the actors and spectators can recount to each other obscene and grotesque incidents in their lives. Amiel, one of the principals, takes charge of this experiment in group therapy. He tells his prison friends that he had a dream about doing a play entitled *and they put handcuffs on the flowers*. He explains how members of the cast would go among the spectators, how an actress would lean her head against the knee of a solitary male member of the audience, and how this part of the play held such great surprise for them because they never quite knew what would happen. While Amiel recounts his dream, it is actually realized. The lighting pattern changes, and the cast takes its place in the scaffolding. This segment is brought to a close by a fight among the members of the troupe, which creates a climate of hysteria touching upon paroxysm.

By establishing a well-regulated audience participation in the theater "game," Arrabal is able to maintain control over the activity and at the same time draw the spectator out of his normally passive role into his own dreams and fantasies and those of his characters. Since members of the audience are separated from their companions, it is hoped that their normal social mask will be lifted and that they will allow themselves the liberty of their dreams.[18]

Arrabal's demands on his audience do not stop with the participation in the action of the play; he insists that it understand the shattering truth of the dehumanizing conditions of prison life in Spain and elesewhere. Some of the scenes of prison life are played in mime by the characters while a voice on the loudspeaker explains: "Each prisoner had the right to only two floor tiles for sleeping space so that they all had to sleep on one side. At night the whole row had to turn to the right when the guard yelled 'to

the east' and to the left when the guard yelled 'to the west.' " [19]
The conditions of prison life are so degrading that reports of man's
first landing on the moon seem unreal and almost ludicrously
absurd in contrast. Arrabal juxtaposes the grandest victory of the
technological era with the sordid life of the prison and thereby
vigorously points out that man's control of the machine has not
prevented him from imprisoning innocent men for political ac-
tivity or from debasing a human being in the dark cells of a state
prison:

*Katar.* Here we are in prison, our ideas forbidden, our nation
    divided, vengeance everywhere . . . it just has to stop.
*Amiel.* How?
*Katar.* A man's on the moon.
*Amiel.* You're the one that's loony.
*Katar.* Do you remember what he said when he stepped on the
    moon for the first time?
*Loudspeaker.* It's a small step for a man but a giant leap for man-
    kind.
*Amiel.* It was a peaceful conquest . . . the first in the history of man.
    It was the first victory not won to the detriment of other men.
*Katar.* But we're still here in prison.
*Amiel.* Such a successful undertaking will make people unite so as
    to forget the inquisitions and the intolerance that have put us
    in prison.
*Katar.* Tell that to the tyrants, to the dictators.
*Amiel.* The time has almost passed when they put the handcuffs on
    the flowers.[20]

As in the plays of his Panic Theater, two series of scenes con-
stitute the basic actions of this play. One deals with actual prison
life; the other, with the dreams and memories of the prisoners.
From a theatrical point of view, the transformations of the charac-
ters during the dream and memory sequences constitute one of the
play's salient characteristics, again very much like the plays of the
Panic Theater. The transformations allow Arrabal to play with the
various rapports between the characters; to work out the permuta-
tions of the "game"; and to create a universe where dream and

reality, past and present are combined in the kaleidoscopic vision that is typically his own.

The play begins when Tosan enters the penitentiary. Word of his arrival quickly spreads to all the cell blocks, for Tosan is a hero to the prisoners. Whereas the great majority are imprisoned for crimes both petty and major, Tosan is a revolutionary. He tried to change the society that creates prisons but was beaten by it. The other characters—Amiel, Katar, and Pronos—have been in prison for about twenty years, victims of a society that has forgotten them. Each of them reacts to their experience in prison differently, but each has had his life transformed by it.

Amiel has learned to suppress his prison experience by means of his dreams, fantasies, or memories. When only seventeen, he was arrested and imprisoned for a minor crime. He has spent seventeen years behind bars when we meet him—a grown man physically but an adolescent in emotional and psychological terms. Because of his limited contact with women and his emotional immaturity, all his fantasies and dreams tend to be sexual. Yet of the three he is a poet, and he shares with his fellows and us his rare gift of language and metaphor:

*Amiel.* I dream of being with a girl who is like a great cluster of life. I dream of tracing circles on her with a compass; I place one leg of the compass on her navel, and with the other I lightly brush her lips and her breast and her sex. And I dream that we kiss and that we offer one another tiny electric locomotives of dew, that we sway on our peaceful happiness, that we shower each other with waves from the sea while thousands of salmon pass between our legs, then I come in my dream.[21]

Katar, on the other hand, is obsessed by the prison itself and the life he leads there. He brings it incessantly into the conversation and even tries to stop Amiel's fantasizing in order to remind him of the reality of the prison. But Amiel refuses to share Katar's obsession, and Katar in his turn refuses to share Amiel's dreams. Katar's obsession with the life of the prison stems in part from the fact that his wife, whom he loved dearly, unjustly denounced him to the political authorities. The situation is similar to the one found in

*The Two Executioners* (1959) [22] and in Arrabal's autobiographical novel, *Baal Babylone*,[23] in which a woman denounces her husband and then urges his guards to whip him. In a dream sequence based on a recollection, Katar asks his wife, Imis, to help him, but she replies sarcastically that he is not worthy of being the father of her children and defecates on his open wounds. During the entire scene, Pronos dances about the stage dressed in a tutu. The juxtaposition of the cruel and the ridiculous, an aspect of Arrabal's taste for the baroque, accentuates the hate inspired by differences in political ideology. Finally, Imis ostracizes Katar from his family and refuses to allow him to see his children.

Katar's dreams, tied as they are to his real-life experience, do not give him any relief from the cruelty of the penitentiary. They only remind him of his wife's hatred for him and of his desire for political liberty. Amiel tells him to forget all that: "You always think about your wife. Forget her. You see how we are: me, I dream about fantastic things, about extraordinary adventures, but you, you turn over in your mind the story of your wife and kids. . . . When your kids are grown, they'll come looking for you. You'll be their idol. And the more she and her family and her friends hate you, the more the kids'll love you." [24]

Pronos, the last member of this trio, is a mute. If he has fantasies or memories, they are not shared with us—save one. At the end of the play, when Tosan is condemned to death, Pronos regains his power of speech. We learn then in a flashback that he lost his voice when, mistaken for another prisoner, he was taken out to be shot. As was the custom, prisoners were muzzled so that they could not shout antigovernment slogans. Fortunately for Pronos, the mistake was discovered before he was shot, but when the muzzle was lifted he could not speak. Pronos is thus held captive not only by the walls of the prison but also by his inability to speak. Nevertheless, he does participate in everyone else's dreams, playing successively the roles of a leader, curé, judge, lawyer, and confessor—all roles that ironically demand a glib tongue.

Tosan, the revolutionary, plays few roles in the dream sequences of the others and has no dream life at all within the framework of this play. His activities deal with the real world of the prison. He

stands against all suppression of liberty and justice, for which at
the end of the play he is garrotted. The last scenes of the work
depict Tosan's life, his discussions with his wife, and finally his
death. They reproduce in fact, the drama of *All the Perfumes of
Arabia*, the guerrilla playlet treated earlier in which the roles of the
church, the business world, and the military in support of the
Franco regime are caricaturized. Whereas the playlet ends with his
death, however, this play does not. When Tosan is garrotted, one
of the women, Falidia, gathers his urine and blood in a bowl, and
they all cleanse their faces with it. Then they carry Tosan's body to
a high platform while singing songs dedicated to freedom, justice
and the beginning of a new era; there Tosan comes to life and joins
in their joyful chanting.

In comparing Tosan with another Christ figure, Emanou of
*Automobile Graveyard*, Bernard Gille suggests that Tosan's resurrec-
tion represents a change in Arrabal's views:

> Jesus no longer dies in vain. Arrabal forgets his pessimism
> in order to present the hope that is born from martyr's blood.
> Tosan, neither murderer nor passive victim, is no epic hero of
> the proletariat either. He is a real man with a real body who
> does not die as in a tragedy. Life flows on, urine and blood,
> like gold mixed with mud, a human stream flowing toward
> death. And when the actors cleanse themselves with this radi-
> ant water, it becomes the first gesture in the ritual of man's
> hope in mankind.[25]

Although the ending of the play, as indicated by the text, leads
one to believe that Arrabal is truly expressing hope for mankind, it
should be mentioned that in both productions of it in New York,
in the fall of 1971 and again in the spring of 1972, Arrabal ended
the play with Tosan's death, a Pietà scene, and not with his
triumphant resurrection.[26] Such an ending is in fact more appro-
priate, for Tosan's resurrection would betray all that preceded it.
There is little in this play that gives cause for celebration. The
imprisonment of men for twenty years in horribly overcrowded
prisons for petty crimes or for their political views should be no

cause for joy. What is remarkable is that these men survive with some dignity intact, that they can laugh and enjoy each other. It is indeed a miracle but not a joyful one.

The interweaving of dream, memory, and reality makes this play one of the most theatrical of Arrabal's works, rivaling even *The Garden of Earthly Delights.* The theatricality of the play flows from the baroque, which stands both as a hallmark of all his theater, indeed all his artistic output, and as a basic element in his revolt against society. For Arrabal, the baroque, with all its emphasis on fantasy and distortion, complements and accentuates the basic thrust of a guerrilla play, since it is the foundation for all revolt within our society, as he states in an interview with Alain Schifres:

> I refuse to picture reality without the fantasies, the monstrosities, the distortions of the baroque. I am absolutely convinced that there do not exist two separate worlds, one real, the other imaginary. That is a schizophrenic vision worthy of this century. . . . Counter to art considered as a catalogue, an inventory, stands another concept: art as a shout or a flash of light that sheds light not only on reality (and its surface) but also on the hidden sector of the unconscious. Standing opposed to a cold, coherent, and repressive art is baroque art, which is an expression of the "pleasure principle," the basis of all revolt against an alienating society.[27]

For Arrabal, then, the baroque as an expression of man's fantasy life is an effective force against an oppressive society.

His taste for the baroque manifests itself in this play in the many grotesque scenes that flow out of the prisoners' fantasies, which are frequently anticlerical and scatologically blasphemous. During a dream in which Amiel plays Our Lady of Fatima reincarnated, Our Lady proves her identity by turning her urine into warm milk chocolate. In another scene, Pronos plays a particularly sadistic prison Chaplain who enjoys whipping the prisoners. The Chaplain recounts that in revenge for his cruelty one of the prisoners urinated into his chalice and replaced the host by a piece of salami. The Chaplain, enraged by this sacrilegious act, had the prisoner

confined for four months without food and water. When the cell was opened, all that was left was a partially mummified body whose arms and legs had been chewed away. The prisoners, infuriated by the story that the Chaplain has told them, crucify him on a saw, tear out his eyes, and castrate him. They then stuff his testicles into his mouth and make him eat them. He responds with this prayer:

*Pronos-Chaplain.* O Lord! I can no longer see. My pleasure has been increased. O what a delight to eat my own balls ripped out in one fell swoop. And without sight, all my enjoyment is concentrated in my mouth, on my tongue. In the mouth that you gave me, Lord. O Lord, thou hast given me my balls and thou hast taken them away! Blessed be thy Holy Name! [28]

The use of a series of scenes based on the fantasies and memories of the characters leads to a sense of fragmentation and discontinuity in the structure of the play, that is, to the chaos and confusion of panic. From the point of view of the new theater, this is one more expression of the rejection of plot or narrative and of a sequential temporal structure, but from the point of view of traditional theater, the multifocus character of this play does not give the spectator time to concentrate on the real problem at hand: the tragic lives of four Spanish prisoners. Expressing this point of view, Walter Kerr, in his review of the play, notes: "Merely kaleidoscopic patterns may be colorful, can be used to while away the time; but they are not affecting. Here brutality is robbed of its impact and its significance by a random, if carefully studied, busyness." [29] Richard Watts of the *New York Post* likewise stated that the play has a "power which is needlessly diminished by his [Arrabal's] insistence on a kind of playful vulgarity that keeps getting in the way of its intensity." [30] It is true that Arrabal's play is difficult, both on the structural level in which a myriad of activities must be orchestrated with precision and care and on the level of the action itself in which Arrabal's fury turns to the brutality of prison life. Moreover, most critics in the traditional school and, indeed, most theatergoers, find Arrabal gratuitously obscene and sensational. Yet one must accept Arrabal's works on their own terms, with their

profanity, their revelations, and their brutality intact. This play is not an easy one to witness, for we are faced with man's savagery and are made aware of horror that we would prefer not to recognize. It is Arrabal's wish that we understand some of the torture that men like these characters undergo in prison. If so, then Arrabal has won his case.

The play in its cumulative effect becomes, as Arrabal wanted it to be, a shout against all that reduces man's basic freedom. Moreover, the transformations of the various characters and the dream sequences make for a rich theatrical experience. Thus, despite its faults, the play remains a powerful indictment of the Spanish government under Franco and of any sort of oppression. As Caroline Alexander stated in her review of the Parisian revival, "And when the footlights dim, the audience, incapable of applause, can only offer its silence." [31]

When not lost in the slogans of the student revolt of 1968, Arrabal's Guerrilla Theater serves to heighten the consciousness of the spectator. It does not, however, mobilize a force against the oppression it decries. This failure stems in part from Arrabal's basic anarchistic stance, which does not permit him to propose a political solution for the injustice he perceives. Complete and untrammeled freedom is his objective as long as it is not harmful to others.

Like most members of the avant-garde, Arrabal's political position appears to be considerably left of center, but on closer examination we note a more reactionary stance. As Richard Coe has so artfully stated, Arrabal, along with Ionesco, Beckett, and Genet, adopts a position that is at once engagé and not engagé from a political point of view, a position that is devoted to mankind but not to a particular group or class; to "progress" but not in a clear and rational direction; to a "politics" that is without party, program, leaders, its own language, and discipline.[32] In fact, if we judge him by his theater, Arrabal is so opposed to intellectual solutions to political and social problems that he frequently takes refuge in a profound pessimism that stands in contradiction to the traditional optimism and progressivism of the Left. Despite this

apparent contradiction, the Guerrilla Theater of Arrabal is an authentic witness to the horrors of prison life in his native Spain and the furor of one of its brightest "flowers."

## Notes

1. R. G. Davis, "Guerrilla Theater," *The Drama Review* 32 (Summer 1966): 130.
2. Pierre Biner, *The Living Theater,* 2d ed. (New York: Horizon Press), 1972.
3. Françoise Raymond-Mundschau, *Arrabal* (Paris: Editions universitaires, 1972), pp. 25-26. All translations are mine unless otherwise noted.
4. Fernando Arrabal, "Les prisons espagnoles," *Le Monde,* October 31, 1967, p. 13.
5. Raymond-Munschau, pp. 27-28.
6. Fernando Arrabal. *Théâtre de guerilla* (Paris: Christian Bourgois, 1969), pp. 117-32.
7. Ibid., p. 120.
8. Ibid., pp. 124-25.
9. Ibid., p. 131.
10. Ibid., pp. 133-51.
11. Ibid., p. 138.
12. Ibid., p. 147.
13. Ibid., pp. 155-68.
14. Ibid., p. 158.
15. Ibid., pp. 171-81.
16. Ibid., Bernard Gille in his study of Arrabal's works *(Fernando Arrabal,* [Paris: Seghers, 1970], p. 114) says that the title is taken from a conversation that Federico García Lorca had with the cartoonist Bagaría in which he said: "Tell the flowers not to flaunt their beauty too much. For they'll put handcuffs on them and they'll make them live under the corrupt winds of death."
17. This production was staged in an old church by The Extension, Inc.
18. Gille, p. 119.
19. Arrabal, *Théâtre de guerilla,* p. 58. According to Bernard Gille, many of the texts read are from authentic material taken from Melquisedez Chaos's work, *Veinte años en las cárceles españolas* (Ruedo Ibérico).
20. Arrabal, *Théâtre de guerilla,* pp. 73-74.
21. Ibid., p. 18.
22. Fernando Arrabal, *Théâtre 1,* (Paris: Christian Bourgois, 1968).
23. Fernando Arrabal, *Baal Babylone* (Paris: Union générale d'éditions, 1971).
24. Arrabal, *Théâtre de guerilla,* pp. 77-78.
25. Gille, p. 117.
26. This second New York production, also directed by Arrabal, was staged at

the Mercer Arts Center without the effective separation and seating of the audience that took place in the first production in the fall of 1971.

27. Alain Schifres, *Entretiens avec Arrabal* (Paris: Pierre Belfond, 1969), pp. 64-65.

28. Arrabal, *Théâtre de guerilla,* p. 38.

29. Walter Kerr, "Doesn't This Playwright Want Us to Care?" *New York Times,* Sunday, April 30 1972, sec. 2, p. 30.

30. Richard Watts, " 'And They Put Handcuffs' at the Mercer O'Casey," *New York Post,* April 22, 1972, p. 19.

31. Caroline Alexander, "Arrabal plaide au palace," *L'Express,* November 6-12, 1972, p. 53.

32. Richard Coe, "Les Anarchistes de droite," *Cahiers Renaud-Barrault* (September 1968): 100.

# 6.

## The 1970s: The Theater of the Sordid and the Sublime

To maintain a marginal position in the theater today and still remain a playwright whose works are frequently produced is perhaps possible only in Paris. Although his plays have been staged often in other great cities, it is Paris that has always offered to Arrabal the opportunity to experiment and to remain at the head of the avant-garde pack. This is not an easy task. However, the very nature of Arrabal's creative vein, his ability to construct the most searing or crass theatrical images, make him anathema to the bourgeois amateur of the theater and to most critics whose love of the well-constructed play remains secondary only to their love of beautiful language in the theater. But Arrabal refuses to be coopted.

If Arrabal's ability to remain at the outer limits of the vanguard solicits our amazement, it does not make of him a playwright whose works necessarily build on previous success. Whereas with most artists one can follow the growth and continued sophistication with the genre and materials chosen for the creative act, with Arrabal there is an annoyingly conscious decision not to follow a successful play with another in the same manner. That is not to say

113

one cannot recognize a work by Arrabal. On the contrary, his surreal language, his biting criticism of all aspects of modern life, and his theatricality mark all his plays as his own. But his continuing search for new ways of approaching the theater and his insistence on experimentation do not permit him to mine a successful avenue of approach for long. As disconcerting as this attitude might be, it makes his theater fascinating.

Although all of his plays of the 1970s contain virulent attacks on modern society, they each take a different stance, and in the case of his most recent plays, contained in a volume entitled *Théâtre bouffe* (comic theater), a decidedly different tone. *Bella Ciao or The Thousand Years' War* (1972), *Heaven and Crap* (1972), and *The Twentieth Century Review or Marie Satanas Is Not So Crass* (1972) concentrate to a great extent on sociopolitical themes intertwined with the ever present influence of the oppressive state. *Bella Ciao,* in a musical revuelike form, deals principally with the influence of the press, sports, and television on contemporary culture. *Heaven and Crap,* more diffuse in its attack, treats sadomasochism, force-feeding of prisoners, the Manson gang, Christ, the Roman Catholic church, the oppression in Tsarist Russia, among many other topics. Harry Truman and Hiroshima, Adolf Hitler in his bunker, Our Lady of Fatima and flying saucers, the Olympic Games, the *Titanic,* Sigmund Freud and the sexual revolution, and the landing on the moon are subjects of the acerbic attack in *The Twentieth Century Review.*

The building of a democratic government under Juan Carlos and Arrabal's attitude as a Spaniard in exile is the subject of *On the High Wire or The Ballad of the Phantom Train* (1974). *The Tower of Babel* (1976) deals in a symbolic fashion with Spain, its present state and its past glory.

Pure panic is more the subject of *Today's Young Barbarians* (1975). The reappearance of Lis and Sil, or Arlys-Sylda, in the form of Ecila (Alice); of a mysterious fellow named Snark; of Dumpty, Tenniel, Chester, and Kitty tells us that we have returned to Arrabal's oneiric universe and all its panic trappings with a good dose of Lewis Carroll. But even here the themes of master and slave and of oppression show their heads.

*Théâtre bouffe* (1978) is the label given to three of his plays, *Steal Me a Million, The Orangutan Opening,* and *Punk and Punk and Colegram.*

These plays contain many of the characteristics of Arrabal's thea-
ter—the zaniness, the absurd, a good bit of surreal poetizing, but
not a great amount of the crude, insistently vulgar and baroque
scenes of his earlier plays. Arrabal relies on his comic vein rather
consciously while attacking some of his favorite bêtes noires.

From a formal point of view, innovations and reminiscences of
previous plays intermingle. As an innovation, *Bella Ciao* is a full-
blown musical revue with its chorus, orchestra, and stars, behind a
concentration camp setting and a corrosive pitch. *Heaven and Crap* is
reminiscent of *and they put handcuffs on the flowers,* since we relive the
memories of five persons who are condemned to die in a series of
juxtapositions and parallel scenes. Like *handcuffs,* the play presents
characters who frequently shift from one scene to another while
still holding on to a semblance of their basic character. In form,
*Théâtre bouffe* represents the greatest departure from his entire
canon, for the plays are constructed like boulevard farces with all
the ends tied together, characters who are painted with large
brushstrokes, and a light, almost bandying tone.

That is not to say that in his most recent plays Arrabal has lost
any of his impact. Ionesco felt impelled to come to his defense
when *Punk and Punk and Colegram* was soundly trounced by the
regular critic of *Le Figaro.* Ionesco said in part, "Behind the laugh-
ter, there is a tough play. It was with pleasure that I discovered
that the partisan critics of Arrabal's first plays were fortunately not
very effective. Young people are attending the play in droves. A
couple of years ago, cloaked in their ideological mythologies, they.
would not have been able to accept, they would not have dared
admit such buffoonery, such derision. The old critics, ill with their
leftist or reactionary attitudes, the old terrorist critics who are now
forty years old, are outmoded and should be discarded in the trash
heap. A new generation is born that has no need of its pitiful
masters, a generation of free men who are not engagés." [1] So
Arrabal, even when he is at his most conventional, can still ignite
the fires of controversy and answer the need for a different, if not
new, view of the world for another generation.

In a prefatory remark to *Heaven and Crap,* subtitled *Memories of
Five Condemned Men on Death Row,* Arrabal reveals, perhaps with
tongue in cheek, his dislike for this play. He says, "I really hate

that play, *Heaven and Crap*. There is no complicity, I believe, with the characters. Erasmo, what a horror! I wonder why I wrote the damned thing. If someone can give an explanation. . . . Write to me." [2]

Like *and they put handcuffs on the flowers,* this play is preceded by a series of preperformance activities during which the members of the audience are led into a darkened room before being taken one by one to their seats on the floor of the completely carpeted playing space. The actors are to bow Oriental style to each spectator while soft Oriental religous music is played in the background. Spectators who refuse to doff their shoes before entering the "holy place" are asked to leave. The actors ask members of the audience if any would like to witness the play while in irons or in a wooden box used for torture. The expected pleas to be released during the action are supposed to add to the heightened religious and theatrical mood that is slowly built during the play's execution.

Obviously, this is no normal play. We are invited into a place separated from the world, a holy place filled with religious incantations, in order to take part in a spiritual meditation. The action begins with a cymbal crash and the crowing of a cock as if to indicate a new dawn, a new beginning. The actors appear in the playing area stripped, their nakedness visually symbolic of their attitude as they enter into the holy place of the ritual. Each in turn will don a large handmade shirt of coarsely woven material, their vestment for the ceremony. A rabbi, monk, or priest is invited to pray during the entire play.

Erasmus, the master of ceremonies, asks the characters to identify themselves. Grouchenka is a slave who was brutalized by her master in Tsarist Russia; Cleaver is an inmate of a Boston prison in charge of washing the dead in the psychiatric ward; Judas and Ribla identify themselves as the little couple who endlessly travel about the globe followed by a horse carrying a skeleton. Each wants to be happy. Each hears the lamentations of those who are lonely and loveless. As a preface to the rite, Erasmus recites the following:

*Erasmus.* The world is a desert where you find neither man nor beast. They buy the fields with money, our souls with vanity,

and contracts are written to buy our hearts. But now I can fly, we can fly like the doves among the marijuana clouds. In a few hours we will be killed. During this vigil we look at the sea and the phantoms. A ship without eyes or face prepares to tear us brutally from this dank mold.[3]

We then enter the lives of each character in a series of scenes that recount some incident in their past. Each scene is rather short and is preceded by a change in lighting pattern and by a short musical interlude. Very little narrative progression and little or no chronological sequence are established. We are in a vague and indistinguishable past, the mindscape of characters where dream and reality intermingle.

Forced to take her mistress' place in bed by the mistress herself and then found out, Grouchenka must submit to the worst sort of depravity at the hands of her master. He gives her almost daily to his friends (as Fando did Lis) and makes her engage in sordid sexual games. But like all master-slave relationships in Arrabal's works, the trick is turned and Grouchenka's master becomes her slave. Ribla and Judas, trying to find their happiness through sex, discover that mutual and simultaneous pleasure is not their lot, even though they confess their affection for each other. They take their sexual problems to Erasmus, who informs Ribla in male chauvinist fashion that women are merely the instruments of man's pleasure:

*Erasmus.* It seems that you are completely perverted by our contemporary world. Look at the submissive women of the villages in the south who await their men while busying themselves with chores that require a cadenced to-and-fro motion, thus preparing themselves for the movement needed for their husband's sexual pleasure. These women scrub and wash and weave. And when night falls, their men fertilize them superbly for their own pleasure.[4]

Cleaver's past surfaces in visions of his brutal force-feedings while women lasciviously danced around him. He recalls his father, a doctor, who took advantage of women and then died at the

hands of their husbands, who mutilated him. Another scene treats a homosexual proposition that Cleaver submits to in prison. In each of these scenes the sexually sordid forms the basis of the theatrical tension Arrabal tries to create.

From the beginning of the play, there is mention of a Messiah. Ribla says that she is going to give birth to a girl who will be as tiny as a flea, ugly as a cockroach, and gilded like a golden scarab, who will be the Messiah.[5] Erasmus tells the other characters that God is with them when they make love, that God is love. Ribla declares Judas the Redeemer; Cleaver becomes Christ and is sold at auction for thirty pieces of silver. Finally, during the homosexual scene in the prison Cleaver has a vision in which he is told he will give birth to the Messiah. These references reinforce the ritualistic atmosphere that is established with great pains in the pre-performance activities.

Erasmus announces the end of the oneiric-sexual feast when he tells them they are to be tried for murder. An offstage voice serves as judge. Erasmus now has become a Charles Manson sort of religious leader, and his cult members do his bidding. He confesses that they have murdered for him. The action reaches an hysterical pitch as the participants cover themselves with bloodied entrails and engage in all types of sexual activity before being mowed down by a machine gun. As Ribla falls to the ground, she gives birth to the long awaited Messiah.

*Heaven and Crap* is composed of a series of scenes juxtaposed in such a way as to emphasize the oppressive nature of prison, both from a psychological and a physical point of view. Thematically, we are dealing with prisoners, their nightmares, their past, their fate, and their fantasies, just as we are in *handcuffs*. But despite all the theatricality, dramatic tension is never realized in this play, for we are never allowed to participate emotionally in the plight of these wretched people. We never learn enough about them to make them sympathetic, apart from the fact that they are prisoners against their will, perhaps for no good reason. Arrabal created a framework from the materials of ritual, but he did not provide enough emotionally dramatic substance to draw us into the world of his characters. The play remains a spectacle whose intentions are, in the final analysis, clouded; it lacks any attempt at reflection

on the situation of the prisoners, and perhaps worst of all, with its emphasis on the obscene and lewd it prevents us from any such reflection. The play remains an unfulfilled promise. Its ritual does not bring about transcendence, only the stifling knowledge of man's baseness.

*Bella Ciao or the Thousand Years' War* gives vent to Arrabal's taste for the spectacular.[6] The piece is a hybrid of the American musical revue and the Chinese revolutionary ballet. In it little escapes Arrabal's eye for the hypocritical or even the appearance of hypocrisy. He attacks with broadsides the pope, the Fascists, the university, and all the institutions of modern Western society. He lauds the people and a long list of revolutionaries. The press, sports, and television provide the basic targets for the inquisition carried out by a character named Culture and his troops of Wretched. Here is a musical revue that has as its goal, not simple entertainment as is the tradition, but severe criticism of Western civilization.

Directed by Jorge Lavelli at the Théâtre National Populaire at the Palais de Chaillot in Paris, the piece had a limited run and a mixed critical reception.[7] Perhaps the fact that *Bella Ciao* was a group effort, as Arrabal states in a slight preface to the text, results in its banality. Moreover, Arrabal's critique of society is so general and broad and so consistently without humor and wit that one can only hope the music and dance of the actual production filled the void. We learn that the worlds of the press, of television, of sports are corrupt; that money is the basic element that makes the world turn; that workers are exploited. An enlightened audience does not need Arrabal to point out injustice but rather the Arrabal who knows how to move us to fight injustice. This scant text cannot do it.

With *The Twentieth Century Revue or Marie Satanas Is Not So Crass,*[8] Arrabal returns to the world of nightmare and fantasy, a world he knows so well and to which he is able to give some theatrical meaning. His tone is still biting, his attitude critical, his subject still sociopolitical, but the play has more coherence and the theatrical aspects of it more substance.

In this review of events in our century, the character, Marie Satanas, provides a unifying element. In the opening scene, we see a quiet girl living and dreaming far from civilization in an ex-

tended family situation with her grandparents, uncles, aunts, parents, brothers, and sisters. She is about twelve years of age but physically well developed. Into this primitive scene of wooden bowls, rough-woven clothes, and thatched roofs comes an enormous car—the latest model—its radio blaring the hot tunes of the day. The "family," angered by the intrusion, first destroys the radio and then tears the unfortunate driver limb from limb. Before they push the car and its bloody contents into a ravine, Marie removes a book entitled *The Twentieth Century in Pictures* from the trunk. A police helicopter hovers overhead for a few moments and then disappears. The family returns to its activities. Marie makes herself comfortable, smokes a joint, and passes into a nightmarish world that begins the revue proper.

Chased by men with hatchets for heads, gorillas tied with electric wires, skeletons, and serpents, Marie finds refuge in the arms of a kind old gentleman who happens to be Albert Einstein. Suddenly a typical Japanese scene appears in the background: samurai, geishas, dragon parades, communal baths, all of which portray a country in harmony with itself and at peace with the outside world. Then the destroyer Augusta appears with Truman and his cabinet on board. He gives the signal to drop the A-bomb (which has obvious phallic proportions) on Hiroshima. When the bomb is dropped and the mushroom cloud rises, Truman and his men are bowled over in laughter. Truman exclaims: "We got 'em all right! What a blowout! More than twenty thousand tons of TNT right in in the ass!" [9] They then sing "Hiroshima," a ditty that only shows their ignorance of the tragedy they just witnessed.

> They'll get up and dance in line
> They'll thank you for the bomb in time
> The one, the only bomb for them
> The bomb of progress and of
> HI-RO-SHI-MA. [10]

The skit ends as Einstein is initiated into the plumbers' union with great pomp. He is named a plumber *honoris causa* with all the rights and privileges of retirement and social security. Hiroshima is still burning in the background.

Like all the other skits in the work, *Hiroshima and Einstein* resembles an animated cartoon with large images juxtaposed. Its force results almost purely from the projected images and their theatricality. There is little space for editorial reserve, since the images themselves clearly indicate Arrabal's intentions: Harry Truman was a misguided, sadistic fool, as were his aides; Japan was a country lost in its own traditions that did not merit the type of treatment it received. Such generalities are perforce difficult to deal with. They are particularly so when the message is delivered almost strictly through visual means. The visual sign overwhelms the communicative act and provides us multiple semantic pathways, all of which can be fruitfully explored. In most theater productions, language places a framework on the semantic field, but with this play, like *Bella Ciao,* language's role is diminished. Consequently, we encounter the sort of savage theatricality that Artaud evidently longed for when he demanded that theater return to its primitive roots.

Arrabal's attack here contains no subtlety. Caricature and parody remain his principal weapons, but the parody is absorbed by the musical sketch form that focuses our attention too much on the comic without permitting us fully to assimilate the harshness of the reality. Not much different are the other sketches in this series. Each has its grotesque character: the blind, the lame, the mutilated in the Olympic Games; the marriage of Hitler and Eva Braun in the bunker just before their suicide; the appearance of the Virgin at Fatima and the exploitive financial deals that follow; the landing on the moon and political assassinations from Bobby Kennedy to Patrice Lumumba. At the end of the sketches Marie is awakened from her pot-induced nightmare only to be led off into so-called civilization by the police.

In his Guerrilla Theater, Arrabal succeeded in focusing our attention on the plight of real flesh-and-blood human beings. He also emphasized our humanity and the fact that we could, except for circumstances, be treated just like the prisoners in *and they put handcuffs on the flowers.* Thus, by using the theater in its very essence—the presence of live human beings onstage—Arrabal touched open nerves in us, moved us viscerally through the theatrical images he created, and eventually brought us to reflection.

Arrabal could have created a successful attack on the evil in our culture in these plays, but he does not. In them we do not encounter moral or cerebral persuasion, nor are we moved by radical acts of theater. The form of the musical sketch or revue cannot support the sort of social critique Arrabal intended. Even if one sympathizes with his motives, the aesthetic weaknesses remain clear and are perhaps unworthy of a playwright who has shown himself capable of shaking us from our moral slumber.

As Arrabal demonstrated in earlier plays, events that take place in his native Spain and his reaction to, if not involvement in, them become matter for his creative talents. Franco's death and the ascendance to the Spanish throne of Juan Carlos, Franco's hand-picked successor, were sure to have an effect on Arrabal. His rapport with Spain had not of course been severed by his exile; it had been deepened. His frequent articles in *Le Monde* and occasionally in the *New York Times,* his outspoken attitude on all aspects of the Spanish political situation, and the championing of the rights of Spaniards to govern themselves freely indicated his affection for his homeland. Yet much of the force of Arrabal's positions derives from the fact that he was in exile. A negative but creative charge results from his being on the other side of the Pyrenees that puts into relief his Iberian character. But it also separates him from the evolving Spain of the 1970s, the Spain of Juan Carlos on the road to democracy. This relationship takes on theatrical form on *On the High Wire or The Ballad of the Phantom Train.*

A melancholy tone, a nostalgia not without charm reigns over this play. Although the action takes place in Madrid, New Mexico, the topic of conversation revolves both implicitly and explicitly around Madrid, Spain. Two of the characters, Tharsis and the Duke of Gaza are *madrileños* who remember Madrid from divergent points of view. Tharsis, a man of about forty, left Madrid at twenty to join the circus. He sees Madrid as an empty city, left by its great artists, abandoned to decay. The Duke is only twenty, yet he is sophisticated and a bit blasé. He feels quite differently: "I don't give a damn about your Madrid. I could care less if the rats devour it, that chains reduce it to bits and pieces, that the prisons overwhelm the entire city, that tyranny torture unto death each and every *madrileño. (He shouts.)* I don't give a damn about Madrid.

Do you understand?" [11] Wichita, a much older man and a high-wire artist, is a native of Madrid, New Mexico. He too talks of the past, of the once thriving mining town, and of how it was deserted by its population when the mine was closed some twenty years previously.

*Wichita.* Madrid was the most extraordinary, the most beautiful, the most captivating city in the world. It was a city of the Princes of the mines, Marquis of the slagheaps, Knights of coal. Yes, in it were contained all the miseries as well as all the grandeur of the world. The best died in the wagons, in the mines, in the pits. And all its inhabitants were changed into artists during the holidays, into musicians, puppeteers; the woman into equestrians, flirts, vamps. All the miners made of Madrid a street fair. Madrid was the most beautiful city in the world . . . and soon, I'm sure, it will be so again.[12]

As the play opens, Tharsis and the Duke are attempting to communicate with someone in the outside world by means of a dilapidated, battery-operated telephone, when they are cut off. The Duke sarcastically goads Tharsis into dancing a *chotis,* a popular dance in Madrid, which Tharsis executes with great anguish. Under a spotlight the Duke shines on him, Tharsis dances and then falls to the ground and weeps. From the pitch-black night they hear applause. Wichita appears and begins to set up his tightrope. Tharsis and the Duke help him enthusiastically. They play the trumpet and the drum while he prepares for his majestic feat. But Wichita is too old to dare the heights and, struggling, he falls to the ground at his first attempt to walk the wire.

The scene is now set for a fascinating pas de trois during which the themes of liberty, death, the role of the artist, and the old and the new Spain are woven together with the memories of Tharsis and Wichita. Tharsis remains the principal character of the trio. His need to "breathe," to experience liberty, prompted him to leave Spain, but his self-imposed exile does not make him completely happy. Through his art he wants to show the inhabitants of Madrid what it means to be free. Moreover, he wants to learn the art of the high wire from Wichita. Balanced on the thin piece of

steel in midair, he feels that he would represent all artists whose creative talents urge them to show others the meaning of freedom. But as the Duke points out, Tharsis is tainted by his own base desires. He is obsessed by his sexual prowess; he likes to seduce young girls and engage in sadomasochistic activities. His desire for Madrid's freedom must remain secondary to his own freedom.

Wichita, a poetizing mystic, attracts and rivets our attention as he vainly tries to reconquer the high wire, despite the fact that old age has robbed him of the physical ability to perform his marvelous feat. Macchabeus Wichita, "the angel of the high wire," grants to Tharsis the knowledge of his art and tells him how to inspire his audience and capture its imagination. When he realizes he can no longer perform, his art lost to physical infirmity, he strips his body nude, dresses himself as a first communicant, and throws himself to the bottom of the mine shaft. There he will be picked up by the mysterious phantom train and ground into dog food. Thus, the last inhabitant of Madrid, New Mexico, disappears, and the once thriving town's history comes to an end.

The Duke is a captive in two senses. First, he has been "kidnapped" by Tharsis so as to blackmail his father; and like Tharsis he is captive of the idea of a different sort of Spain, one not charged with the Francoist ideas of Fascist loyalty nor with the ideas of the new bourgeois capitalists, their greed and hypocrisy. He does not propose another sort of Spain; he merely criticizes the present one. In the end, he acts as a foil for Tharsis's illusions and delusions.

Arrabal has simplified his dramatic situation to the extreme, as he does in his most successful plays. Tharsis's quite plain desire for the freedom of Madrid runs counter to his desire for his own personal freedom. He left Spain in order to find freedom and must remain outside Spain or risk being coopted. In a sense, Tharsis's ideas of Spain as a continuous panic feast find opposition in all the other ideas that are explored here, from greedy capitalism to strict fascism. Will Madrid, Spain, become another ghost town, spiritually if not physically? This is the central question of the play. No answer is provided, but Arrabal, through the character of Tharsis hopes that his native country and its capital will fulfill his dreams.

*On the High Wire* comfortably takes its place in Arrabal's canon.

The characters exist in a marginal area, separated from the real world by their own illusions and fantasies. Their search for identity is outside the confines of society, and like their predecessors they are innocent-but-guilty. They are free yet imprisoned. For them the outside world remains threatening, and as we see when a helicopter gunship attacks in the final scene, their fear is justified. Like the children of paradise of Arrabal's first plays, or the candidates for initiation of his panic world, Tharsis, Wichita, and the Duke are thoroughly theatrical. They are circus performers or spectators. They use juggler's rings, the tightrope, and a spotlight. They are constantly onstage. They are creators of illusions and are illusions themselves. The theatrical quality of the characters marks the play as typically Arrabalian and contributes to its charm and success.

To a great extent, *On the High Wire* becomes both a confession and an exorcism. In it Arrabal the creator-artist confesses that his need for liberty outweighs his need for cultural support in his native Spain. It is an exorcism in that he publicly frees himself of his own illusions concerning his relationship with his homeland. He has objectivized and placed some distance between his anguish and that of the new Spain emerging after four decades of oppression. He himself can never be free of the cultural ties that join him to Spain, but his creative talents are not totally dependent on it. He is the high-wire artist of his own drama.

Spain also serves as principal topic of *The Tower of Babel*.[13] It is transparently hidden in an allegory in which Latidia, a blind eccentric, attempts to save the castle of Villa Ramiro from the hands of the Count and Countess of Ecija, who have just purchased it at a tax sale. The castle's beams are slowly being devoured by termites, and we hear the results of their work as they slowly encroach on the master beam of the old edifice. Undaunted by both the Count and the termites, Latidia cries to one and all within earshot to help save the castle in the name of honor. She repeats several times, recalling La Pasionaria's call to arms, "It is better to die on your feet than to live on your knees."[14] Invoking also the names of Spanish military heroes, of artists, philosophers, and saints, especially Saint Teresa, she makes it clear that the time has come to save Spain, not just the crumbling castle.

Responding to her call for aid and succor come three picaros,

the One-Eyed Fellow, the Legless Beggar, and the Drunken Slut. They are transformed by the blind Latidia into Ché Guevara, the Cid, and Don Juan. The Marquis, a friend of the Count who was to handle all the details of the sale, finds that he must participate in Latidia's delusions. He promptly becomes Cervantes and then later is called upon to play Valle-Inclán. A paid hit man, whom the Marquis has called in to rid himself of the zany Latidia, becomes against his will Emiliano Zapata. The Count of Ecija must play Goya, while the Countess plays Doña Chimena. Mareda, Latidia's servant, must play the role of Teresa of Avila. Latidia's fantasies do not end with the transformation of her guests into the stars of Spanish history and literature. She has a visitor from outer space—a Martian in the form of a donkey—who lives on the ramparts of the castle and serves as her lover.

Once the three beggars arrive on the scene, we become entrenched in an oneiric world where fantasy and reality are not clearly delineated; where sexually outrageous behavior becomes the norm; and where all the characters, despite their diverse social backgrounds, become totally attached to each other and to the concept of a new castle—that is to say, a new Spain. While the Legless Beggar ties up the Countess and proposes a variety of sexual activities, her husband in turn is seduced by the One-Eyed Fellow. The sadomasochism here, however, is almost playful, since the Count and the Countess resist only enough to make their crippled "master's" efforts sexually exciting. Meanwhile, the Marquis dons a first comunicant's dress and the Martian-donkey is dressed as a bride. When a voice from the outside world warns them all that the castle is about to fall in ruins, Latidia and the Martian—now a man—descend into the cellars of the castle and into Spain's past in order to find plans for the Tower of Babel. After the castle collapses in a heap, Latidia and the rest emerge covered with dust. She has regained her sight, and the others are now convinced that they *are* the roles that Latidia assigned them. They rebuild the castle in the form of the Tower of Babel, and when it is finished they mount gloriously into the heavens to the strains of the *Magnificat*.

The superb eagle's nest with its crumbling timbers that is the castle at Villa Ramiro might seem an unlikely metaphor for a

country that is successfully making itself into a modern demoracy. Yet we must consider that Arrabal's political viewpoints are not those of the majority of Spaniards and that his political concepts are thoroughly imbued with aspects of panic feastings and orgies of chance and confusion that lend little to the practical political realities of everyday government. Nevertheless, from a theatrical point of view the castle does represent the old Spain, and its termite-ridden beams clearly indicate that it is falling apart. The scene in which the Marquis and the would-be killer unearth the bodies of bishops and admirals of the old order only to be overwhelmed by the stench demonstrates theatrically how Arrabal feels toward the figures of authority of the traditional Spain. But from the rubble a new Spain will rise phoenixlike in the form of the Tower of Babel.

This new construction is one of Arrabal's panicky tricks. Whereas the Tower of Babel of the Old Testament represents mankind's divisions, the new tower symbolizes man's reconciliation. The rich and the poor, the nobility and hoi polloi, the young and the old, the maimed and the whole—all work together in building the tower that will permit them to enter a new paradise. Arrabal transforms his characters and makes them well; he also transforms the biblical tradition and forces it to serve his needs— the resolution of all oppositions.

To reach the sublime, we must plod through the sordid. The One-Eyed Fellow, the Legless Beggar, and the Drunken Slut lead the Count and the Countess through all the permutations of their sadomasochistic and sexual games. Their hate is turned to love as they unwittingly come to recognize the good in others. Even Latidia must be cleansed as she descends into Spain's past, into a Dantesque inferno. The sordid and the picaresque become one with panic as all the characters are eventually transformed into representatives of the panic world of playful innocence and androgynous integrity.

Beneath its political exterior, *The Tower of Babel* hides a panic message. Latidia lives in her illusions like Lais in *The Garden of Earthly Delights;* she is a creator of illusions both for herself and for others. She comes to a realization of the real meaning of her existence through the love of her donkey-Martian, who also

prompts her to save her castle, Spain. And like Lais, she enters into the earthly paradise of her dreams when she has completed her self-exorcism. Her language reflects both her fantasies and her political leanings. She quotes from Victor Hugo's poetry of exile—a poetry in which he frequently attacks tyranny and praises freedom, or from François Villon's nostalgic verses about fleeting days. In an amorous moment she recites a love sonnet of Pierre de Ronsard to her donkey-lover. She remains separated from the world and thus joins a long list of principal characters of Arrabal's theater.

In both *On the High Wire* and *The Tower of Babel,* Arrabal's position vis-à-vis the new Spain is clarified. He supports neither the old Spanish authority nor the new Spanish capitalism. Arrabal's feelings for Spain are obviously deeply embedded in the cultural heritage of the country that gave the picaresque tradition to Western civilization. Arrabal takes what is most grotesque in that tradition and makes it his own. He also takes to himself the vibrant, ardent mysticism of Teresa of Avila and secularizes it to make it conform to his own needs for integrity of mind, soul, and body. However, he does not accept a solution for Spain's problems in the practical realm and holds out only the possibility of a secular paradise. Tharsis and the Duke are saved from annihilation because the birds of the air come to their aid and shield them from the helicopter's bullets; Latidia and her group are saved from death by nothing more than the will of the playwright. In both plays the issue of Spain arises and plays an essential role, but Arrabal's world of panic illusion, of chance and confusion eventually overwhelms any need to deal with real solutions in a real world. In a sense, the political question is not properly framed in the world of panic, just as the musical revue cannot properly treat the issues raised in *Bella Ciao.* Form and content do not complement each other.

To what extent do these two plays succeed? *On the High Wire* charms us with its melancholy recollections of the past glories of Madrid, as well as its childlike characters taken up with the glory of high-wire dancing. As a theatrical expression of Arrabal's personal anguish, the play succeeds in making us participate in the world he has created and lifts us out of ourselves. Likewise, *The*

*Tower of Babel* engages us in the fantasies of Latidia, her struggle with the authorities, and her hopes for the future. But it is eventually disappointing, for the major issue raised in the play is not so subtly avoided. Panic and politics do not mix.

*Today's Young Barbarians* tells of a panicky drug trip by Tenniel, Dumpty, and Chester during which their present situation as put-upon professional cyclists is gradually revealed.[15] The play contains more hermetically surreal poetry than any other play of Arrabal; it is one of the most explicitly sexual, calling for several onstage orgasms; and in a delirious fashion it fuses bits and pieces of Lewis Carroll's *Alice in Wonderland* with Christ's Passion and death and scenes from a bicycle race with Dracula as the leading cyclist. The piece is meant to outrage and entice at the same time as it builds unflaggingly toward its furious and infuriating denouement.

Upon entering the theater proper, the audience is treated to a languid love song by the enchanting Ecila, who does not have time to finish her long lament before the spotlight grows dim and leaves her in the dark. From the back of the theater a small pocket flashlight brings our attention to Chester, Dumpty, and Tenniel, who grope their way to the stage, surprised that they have been sent to a theater but delighted all the same. Dumpty is a blind former professional cyclist who has become a masseur and trainer for Chester and Tenniel. Chester is freaked-out on amphetamines fed to him by Dumpty. Tenniel, a father and a mother figure to his two companions, is so absorbed by his own overwhelming sexual urges that he remains in a state of constant sexual excitement. Moreover, he spares us little in his long monologues in which he describes his sexual fantasies and adventures.

Snark, who never appears, stays in communication by telephone with his team of cyclists. He orders Chester to continue popping pills and tells them where and when they are to bed down. According to Tenniel, Snark lives in splendid luxury while they must accept makeshift quarters. Chester and Tenniel work themselves into a fury and swear they will kill Snark in a most horrendous fashion.

Chester, between hysterical bouts, worries about his health—his

urine is blue—and talks of his encounters with a White Rabbit who is always in a hurry. Tenniel continues to weave his sexual fantasies in ever larger and more explicit tableaus, as Dumpty massages him into an orgasmic fit. Apparently oblivious to the futuristic scene before her, Ecila returns, takes her place nonchalantly in the spotlight on center stage, and sings:

> Papanicaille, butterfly king
> Nicked his chin, but didn't feel the sting
> Pear, apple, prune, apricot
> Papanicaille is going to pot.[16]

Despite her efforts at entertaining the threesome, Tenniel ejects her bodily.

Then Kitty arrives. Kitty is more to the liking of the young barbarians. Like her female predecessors in Arrabal's universe, Kitty has been kept a virtual prisoner by her mother. She is one of Arrabal's children of paradise—young, seductive, and innocent. Tenniel, seizing the moment, immediately asks her to go to bed with him, and they go through the childish game of showing their genitals. Within a moment all of them are seated at a table for tea, which they drink with abandon while putting away enormous quantities of preserves at a diabolic rate. Ecila reappears and once again begins her enchanting song. This time she and Dumpty leave together, and in his surreal manner Dumpty recounts how he came to lose his sight in a bicycle race and how Snark came to his aid.

Kitty meanwhile has found a tiny door and key through which the White Rabbit passes. She finds a vial and drinks its contents and gets smaller and smaller—small enough to enter the world of the rabbit. There she sees the bicycle race which Snark-Dracula is winning because he is sucking the blood of the other contestants. Chester and Tenniel are also involved in the race, but Chester suddenly becomes a Christ figure and is crowned with thorns. Just as suddenly in the fury of the race, Chester and Tenniel decide to take out their hostilities against Snark by attacking his emissary, Dumpty, whom they castrate. As the play and the race end, Ches-

ter falls from his speeding cycle and, like Dumpty, is blinded. In his blindness, though, he brings light to the others as he distributes candles to all.

The curious mélange of characters from the various works of Lewis Carroll, from *Alice's Adventures in Wonderland* to the *Hunting of the Snark,* along with references to Sir John Tenniel, Carroll's illustrator, and the reenactment of the Mad Tea Party, fit perfectly into Arrabal's panic world. Like most of Arrabal's characters, Carroll's creations too are participants in a madcap adventure in which marvelous transformations, disappearances, and epiphanies propel them into a strange world of disorder. But whereas Carroll's friend, Alice, returns to the real world, Arrabal's characters do not. They seem to have been born in the theater, live out their existence before us, and then disappear into the darkness.

Moreover, whereas there is a subtle sexuality graciously hidden below the surface of Carroll's illustrations (not Tenniel's) and text, there is nothing subtle about the hard-core pornographic display that *Today's Young Barbarians* calls for. Tenniel's long monologues could easily serve as scripts for the most explicit blue movies. But then, as the title of the play indicates, we are dealing with a contemporary brand of uncivilized savage.

Although one can hardly point to any dramatic conflict in the usual sense in a play that is composed of bits and pieces from various sources, the play does nevertheless have a structuring element that holds it together. Explicitly, the conflict between Dumpty's insistence that Chester be given his daily regimen of pills and Tenniel's equally adamant insistence that he not be serves as a centripetal force of some coherence. Implicitly, though, the conflict between Chester, Tenniel, and Snark over the latter's oppression of those on his team leads to the brutal torture of Dumpty. The steps leading to the torture are not constructed on a series of logical premises; rather, they build around the explosive scenes during which Tenniel exploits all the madness of his hysterical, pornographic imagination. Whereas the force of these explosive scenes provides structural coherence to the play, on a thematic level these scenes represent the breakdown of the relationship between leader and followers, between master and slaves. Unfortunately, the two

conflicting forces are not reconciled in the piece, since the force calling attention to Tenniel's orgasmic explosions masks the fury resulting from the social inequity.

If Arrabal is attempting to make a theatrical statement about man's oppression of man, and thus about man's rightful freedom and dignity, he fails. That failure comes about principally because he does not give real substance to the struggle between Chester, Tenniel, and the elusive Snark. Arrabal refuses to allow his fantasy world of panic to be transformed either by the social or the political. Although Arrabal is conscious of the impact that theater can have on the real world, since it is its mysterious double, he too frequently mitigates that impact by imposing on his characters and on his audience his own pornographic fantasies. The hazy, drug-filled world of *Today's Young Barbarians* is a reality too harsh to hide behind panicky theatricality.

With *Théâtre bouffe,* could it be that Arrabal himself has undergone a panicky transformation, that he has momentarily left behind him the marginal world of so many of his characters and has made a concession to popular taste by adopting some of the tricks of the boulevard farce? Could it be that Arrabal has pushed aside his bitter sarcasm, his pathological sexual fantasies, and has attempted to bring us into his world through zany comedy? Now that he has entered the mainstream as the chess columnist for *L'Express* and has moved from the tenth to the eighth arrondissement in Paris, has Arrabal the playwright been coopted? The plays in *Théâtre bouffe* seem so much more inviting than *Today's Young Barbarians,* for example, that we must suppose a change in Arrabal's attitude. Arrabal, however, has not taken a neutral or passive position on problems he perceives in the social fabric of or society or on the political scene. Rather, he has artfully combined his critical attitude with the forms of the well-made play and is engaged in entertaining his audience—perhaps a newfound one—in his own peculiar surrealist manner.

The three plays included under the title *Théâtre bouffe* are comedies that have at their center the traditional quid pro quo that sets up an entire parade of comic situations. In *Steal Me a Million,* Maurice Viscera, a scientific researcher, needs only a giant computer worth a million francs to make a spectacular breakthrough

in DNA molecular research. Alain, his friend and professor at the Sorbonne, who is a perfect look-alike for El Malagueño, a bull-fighter of repute, poses as the matador, steals a painting, sells it, and cops the million needed for the computer. In *The Orangutan Opening* the action revolves around Mathilda, the chess champion of Europe, who is too perfect for her lover, Jean-François. When-ever Mathilda's perfection becomes too much for him, Jean-Fran-çois dunks himself in the Seine. Mathilda, tired of Jean-François's petulance, decides to plan an "imperfection" by placing Teddy, an American chess champion from Brooklyn, in her closet where, of course, Jean-François finds him. Jean-François, thinking that Mathilda is mad and a raging sadomasochist, calls a psychiatrist. By chance a local call girl, Lulu, arrives at the address believing it to be the home of one of her vicious clients. She is taken for the psychiatrist, and there begins a succession of scenes based on mis-taken identity. In *Punk and Punk and Colegram,* Teran, a Chilean spy, and Federoff, a Russian spy, are lodged in adjoining rooms. Teran is lured into Federoff's room when he hears what he believes to be a soprano practicing her role as Cho-Cho San in Giacamo Puc-cini's *Madama Butterfly.* Federoff, who is doing the singing while trying on a dress he bought for his wife, takes refuge beneath the covers of his bed when he sees Teran. When enticed to come out, he lies and says he is really a bandit. Teran, not to be outdone, avows that he is an escapee from a circus. The two decide to exchange rooms so as not to be discovered. The quid pro quo situation results. In each play the initial case of mistaken identity multiplies, creating a hall-of-mirrors effect.

The complications of the plot scheme in the plays give Arrabal ample opportunity to get off a few rounds on topics dear to him. *Steal Me a Million* gives treatment to women's liberation, the effects of Vatican II, ecology, incompetent government ministers, kidnap-ping, DNA research, plus all the worn-out slogans of the 1968 rebellion. In *The Orangutan Opening,* chess, one of Arrabal's passions, is at the very center of the action. But the Parisian underworld, its colorful language and its murderous ways become just as impor-tant when Teddy's chess pieces are found to contain 100 percent cocaine. The sexual revolution of the 1960s and 1970s also receives considerable attention when Lulu arrives and takes on Jean-Fran-

çois; and later when Prosper, a pimp, comes on the scene, Mathilda finds that the help she has called for is more suited to the massage parlor cum house of prostitution. In *Punk and Punk and Colegram,* Melato, a secret agent, arrives to tell Teran (Federoff) to accompany Bertolo, a Eurocommunist, to Moscow. Bertolo's appearance leads to a long attack on Eurocommunism and the new French philosophy a la André Glucksmann and Bernard-Henri Lévy.

The characters in these plays distinguish themselves from the typical Arrabalian character in that they are basically part of the social fabric. They are not separated from society, as are the adult children who live in marginal areas of society such as automobile graveyards, nor are they the panic characters who escape from reality into their dreams and fantasies. In *Steal Me a Million,* Maurice Viscera, who appears to be locked in his laboratory far from society, is in fact working on a discovery that will have an extraordinary effect on society, that is, the transformation of evil individuals into socially acceptable ones with a few Orwellian twists. Alain, his friend and factotum, remains a respected professor at the celebrated Sorbonne. Even Denise and Paula, two liberated nuns, are politically involved with extreme left-wing groups trying to bring down capitalism. In *The Orangutan Opening,* the characters are certainly members of society, if a bizarre mix of chess champions, pimps, and prostitutes. And finally, *Punk and Punk and Colegram* sets us plainly in the political struggles of Western Europe with Federoff and Teran, two government agents.

As is usual with Arrabal, there are few attempts at psychological portraiture. The characters are drawn with large strokes and given only a minimal number of elements to support their existence. In a sense, it is not of great importance that these characters be someone, but rather that they act and interact with the other characters in the complicated plot. To give such characters too much depth would be to charge them beyond their abilities and would consequently restrict Arrabal's freedom of manipulation as he proceeds toward his absurdly comic ends.

Despite their superficiality, Mathilda, Jean-François, Dr. Viscera, Alain, Teran, and Federoff do have some representative qualities. They live, as we do, in an absurdly complicated technological world where rapid change is a matter of course. Lulu, the

prostitute, is taken for a psychiatrist; Prosper, the pimp, is a detective; Federoff, the spy, is an opera singer; Denise and Paula are ecologists. Arrabal has freed himself from the panic ritual only to show us that our lives are not too far removed from the lives of his characters and their rapid transformations, that panic was not his creation but rather a reflection of our lives. Indeed, we are dealing with "tough plays," as Ionesco puts it, tough because they reflect too closely the real society behind the chrome glitter and smooth plastic.

These plays have all the earmarks of the situation comedy. The plots are complicated, the characters light, the themes current and popular. Yet there remains an underlying darkness, a foreboding that all is not well. In *Punk and Punk and Colegram,* the foreboding ends in the murder of all the characters just as they are about to set out on a journey to fulfill all their dreams. As Federoff, Teran, Melato, and the others decide to leave the life of spying and intrigue and become acrobats, fire-eaters, and flea trainers, a punk band—whose members have green hair and wear outlandish clothes but are really members of the KGB—mows them down. In *Steal Me a Million,* Viscera's discovery is used to give all criminals a disease instead of a prison term. Alain, who unfortunately was sent to prison for his theft, appears afflicted with Saint Vitus's dance. Meanwhile, Viscera is already pondering another invention dealing with the nervous system. Perhaps farfetched to some, such possibilities are tantamount to reality in a world where scientific discovery seems divorced from morality. Even *The Orangutan Opening,* which leaves the characters lost in a cocaine dream (they have mistaken the cocaine for sugar and used it in their tea), finishes with a gun battle between rival gangs. Its lighthearted game of chess has turned into a murderous shoot-out. Behind the comic mask is a mask of fear.

Unlike the boulevard farce where the increasing complication of the plot, the mistaken identities, and the ever faster pace lead to a happy ending, in these plays we are left only with the murderous confrontation between rival parties or with increased complication. Arrabal allows neither his characters nor us to escape.

The thrust of Arrabal's theater in the 1970s remains essentially critical of society. *Bella Ciao, Heaven and Crap,* and *The Twentieth*

*Century Revue* take corrosively vigorous stands against the growing influence of the state in men's lives. *On the High Wire* and *The Tower of Babel,* despite their nostalgia about the Spain of the past, criticize the governments that bridle Spanish culture and the individual Spaniard. Even *Théâtre bouffe* hides a critique of the modern world under its comic guise, and *Today's Young Barbarians,* a tour of Alice's wonderland with Arrabal as guide, paints a picture of sports competition as capitalistic exploitation and class struggle. Arrabal's stance remains essentially the one he cut out for himself in his Guerrilla Theater, where the state as well as all other forms of authority are soundly condemned.

In *On the High Wire* and *The Tower of Babel,* however, Arrabal addresses the problems of Spain and its culture and his relationship to both the old and the new Spain more explicitly than in any other work. In *On the High Wire,* we see a tripartite Arrabal nostalgically honoring the living Spain of tradition, the modern Spain of change, and Arrabal's personal Spain of exile. Under the revolutionary face of *The Tower of Babel,* we find a reactionary Arrabal who takes a stand for the preservation of the essence of Spanish culture.

In the theater of the sordid and the sublime, we encounter some themes that Arrabal treated earlier, but here he has left behind the abstract quality he inherited from the Theater of the Absurd of the 1950s and has constructed a mixture of panicky realism and an abrasively critical stance toward society. Formally, the plays are marked by an incessant taste for the experimental with continued emphasis on the fabrication of theatrical images of frightening excess, which even in failure are impressive. In his search for new forms in his theater, Arrabal has run the gamut from musical comedy to boulevard farce. The form he has chosen for his plays has not always fit the function. He distracts our attention from serious themes worthy of investigation by his playful attitude toward form and by his continued fascination with the pornographic. He provokes his audience and tries its patience with his excess and thus remains in the long tradition of the avant-garde. But Arrabal has not been coopted.

## Notes

1. Eugène Ionesco, "Une cure de désintoxication," *Le Figaro,* December 13-14, p. 27. All translations are mine unless otherwise noted.
2. Fernando Arrabal, *Théâtre 9* (Paris: Christian Bourgois, 1972), p. 21.
3. Ibid., p. 29.
4. Ibid., p. 42.
5. Ibid., p. 30.
6. Fernando Arrabal, *Bella Ciao ou La Guerre de Mille Ans* (Paris: Christian Bourgois, 1972).
7. François Regis Bartide, "Un art consommé qui se consume vite," *Les Nouvelles littéraires,* March 13-19, 1972), p. 24. Bertrand Poirot-Delpech, "Bella Ciao, d'Arrabal et Lavelli," *Le Monde,* (March 4, 1972), p. 21.
8. Arrabal, *Théâtre 9.*
9. Ibid., p. 113.
10. Ibid., p. 114.
11. Fernando Arrabal, *Sur le fil ou la ballade du train fantôme* (Paris: Christian Bourgois, 1974), pp. 15-16.
12. Ibid., p. 16.
13. Fernando Arrabal, *La Tour de Babel* (Paris: Christian Bourgois, 1976).
14. Ibid., p. 27. La Pasionaria (Dolores Ibarurri) was famed for her impassioned speeches during the Civil War.
15. Fernando Arrabal, *Jeunes barbares d'aujourd'hui* (Paris: Christian Bourgois, 1975).
16. Ibid., p. 20.
17. Fernando Arrabal, *Théâtre bouffe* (Paris: Christian Bourgois, 1978).

# Conclusion

Born of passion, pain, fire, the memories of his childhood and the Spanish Civil War, Arrabal's theater represents a special moment in the development of the avant-garde theater in this century. Once shunted aside as a minor element of the so-called Theater of the Absurd, in sheer size his theater has grown to fourteen published volumes, developed an international reputation that touches al¹ the continents, and causes an uproar as a succès de scandale whenever a major production of one of his plays is mounted. This does not, however, prevent his theater from sometimes being wrongheaded, banal, boring, and muddled in its outlook. Interesting ideas sometimes become entangled in the wreckage of their own rhetoric or sufficiently blurred by Arrabal's wanton use of the banally pornographic to leave even the most hardy fan of his brand of theater somewhat jaded. But his theater can no longer be ignored. He has brought life to an art that seems at times to have been left untouched by the extraordinary developments in the arts in the twentieth century.

✓ Arrabal's theater, even when it is closest to the absurdist tradition, possesses marked characteristics. It has the obtrusive odor of

sulfur about it; it is blasphemous, obscene, bawdy, and outrageous; and yet it has an unmistakable charm of its own. Arrabal was able to brew this mixture of charm and blasphemy thanks to the creation of the adult children such as Fando and Lis, Emanou and Dila, Fidio and Lilbé. These characters, sometimes capable of a demented cruelty that is difficult to find elsewhere in the avant-garde theater, are also the givers and receivers of a guileless, tender love. As they wander through the marginal areas of society looking for some type of fulfillment or satisfaction that children are wont to hope for, the realities of an adult world—of the forces of order and oppression—are frequently all they find. Although reminiscent of Beckett's couples, Didi and Gogo, Clov and Hamm, their resemblance to Buñuel's street urchins and to Pablo Picasso's *saltimbanques* becomes apparent as they play their delightful games that soon turn to murderous forays into a baroque and macabre world of juvenile crime and passion.

The erotic cruelty; the mad tenderness; and the games of innocence, guilt, and pardon within a metaphoric framework give way in his Panic Theater to a series of rituals that lead his adolescent characters to the knowledge of love and panic. His plays become fast-moving, kaleidoscopic visions that create the chaos and confusion that stand at the center of his panic theories. His characters become interchangeable; they are subject to rapid transformations; and, like the Emperor and the Architect, they occasionally exchange personae. The entire panoply of secondary effects, of lighting, slide projections, film clips, helps to create an atmosphere of a world gone wild. The Panic Theater is a visual feast that tends toward the spectacle and, perhaps more important, brings to the theater a technique of scenic juxtaposition that used to be the sole reserve of the cinema.

Yet for all its richness from a theatrical point of view, the Panic Theater can be singularly void of any substantive ideas. What human being, for example, would not want to be both omniscient and free of any fetters on sexual and social behavior, as is Giafar at the conclusion of *The Lay of Barabbas*. One may be amused by the sheer spectacle presented here, but the poverty of language eventually takes its toll on our attention and concentration. One longs for the charm and innocence of Arrabal's children of paradise. Yet

when the Panic Theater succeeds, as it most certainly does in *The Architect and the Emperor of Assyria,* the effect is a profoundly meaningful metaphor about the human condition, its joys and its pains.

While maintaining the ceremonial aspect of his Panic Theater and its transformations, in his Guerrilla Theater Arrabal explores some of the more pressing social problems of the contemporary world, and especially of Spain during the regime of Francisco Franco. He presents a stinging indictment of prison systems, tyranny, and oppression. He tries to create a theater that is a means of mobilizing public opinion, a consciousness-raising act, a prod to action for or against some aspect of the social or political status quo. Whenever his own fantasies do not set the picture awry, he succeeds remarkably well in emotionally involving us in the lives of the oppressed and of those hungry for freedom.

The importance Arrabal gives to ceremony in both his Panic Theater and his Guerrilla Theater makes him part of the efforts of many playwrights and directors who attempt to make the theater return to its roots and away from the storytelling dramatic literature that is of more recent vintage. Jerzy Grotowski, Jodorowsky, García, Lavelli, Savary, Peter Brook, and Richard Schechner as directors and leaders of troupes have contributed their talents to this movement toward a ritualistic and communal theater. Their success can be measured in the number of plays even in the naturalistic mold that use the ritual and ceremony as an underlying structure.

But we cannot overlook the role the writings of Antonin Artaud have played in this movement. Misunderstood by some, revered by others, Artaud has become the excuse for all experimentation in the theater today. The worst excesses and the most stunning successes find their source in Artaud's *The Theatre and Its Double.* Arrabal fortunately has benefited from the freedom to experiment with all the various elements of the theater that Artaud's works have instilled in the contemporary scene. If he himself has not gone to that source of imaginative and poetic thought on the theater, he has surely felt its impact. The best productions of his works are staged by directors who are in debt to Artaud, since Arrabal, like Artaud, wants to create a world of chaotic illusion and confusion,

of gesture and cacophony, of dreams, nightmares, and poetry that would lead to a communal theatrical experience.

A member of the panic group, Jérôme Savary, who directed a London production of *The Labyrinth* in 1968, tried in the Artaudian sense to create the atmosphere of an unbridled circus gone wild that would bring about the type of tribal excitement associated with primitive theatrical spectacles. James Roose-Evans describes some of the activities directed by Savary, who was suspended upside down above the audience or hanging from a wobbly ladder during the production:

> There is generated an atmosphere of extraordinary tension and excitement. A girl has a real orgasm; at one performance, a youth masturbated. There is a great deal of near nudity, and at one point, a young man tears off his loin-cloth, holds his penis in one hand, then grabbing a rope swings out over the gasping audience as drums beat and lights flash. Sometimes the near-naked actors spill out on the rain-wet London street, startling passers-by . . . the audience forgets time, caught up in an atmosphere of fun and exuberance which is a mixture of fiesta, carnival, cabaret and nightclub, fairground, dance-hall, orgy and revival meeting.[1]

Given to exaggeration or not, Mr. Roose-Evans certainly captures the spirit of Savary's and Arrabal's conception of the world of panic.

For his production of *Automobile Graveyard* in Dijon in 1966, the Argentine director Victor García created a playing space with U-shaped walkway, a multilevel stage, and old automobile carcasses hanging from the ceiling. When it was restaged in Paris at the Théâtre des Arts in December 1967, some of the public was seated on swivel chairs that permitted them to follow the fast-paced action that took place about them.[2] They were treated to a spectacle that included strident screams and an almost continual clanging of metal—a spectacle that Gabriel Marcel called "a degrading technique." [3]

García, whose French at the time was minimal, cared little for

the text per se: he interposed within its action both *Orison* and *First Holy Communion.* Although he changed not a word of the original text, he was obviously more interested in its structure, which could be re-formed to fit his scenic demands and needs. Like Arrabal, García seems more intrigued by the structure of a work, its theatricality, and its scenic vision rather than by its linguistic thrust. He is one of the directors who can easily synthesize Arrabal's conceptions with his own; and this he does, thanks to the freedom that Artaud, through the influence of his writings, has wrought in the contemporary theater.

Similarly, Arrabal, in his own production of *and they put handcuffs on the flowers* experimented with the theatrical environment. A darkened room provided an entrance into the playing space proper. There the actors led the audience one by one, separating them from the real world of their friends and their work and into the "real" world of Arrabal's prisoners. The spectators then were shown to their places on a scaffolding set up around the playing space.

Arrabal's direction, not surprisingly, emphasized the performance rather than the text. Movement that becomes dance, dance that becomes ritual, language that becomes poetry, poetry that becomes music and incantation—these are what he strives for. Some forms of theatrical experimentation discard the text entirely, but for Arrabal it remains the starting point of a process in which directors and actors seek out various ways of "doing a play." As we have seen, Arrabal's emphasis on a particular type of surrealistic, poetic language prevents him from abandoning the text completely.

Arrabal's experimentation has also led to an attempt to alter the relationship between the audience and the performer, especially in the plays of his Guerrilla Theater. He tries to include the audience in the theatrical event by giving its members an opportunity to speak and to share their dreams and fantasies with the group. By doing so he has also changed the relationship among the spectators and has tried to move them away from their normally passive posture.

In effect, Arrabal has experimented with most of the permutations that the theater "game" allows: he treats the text as a *pre*text

for theater; he attempts to alter the relationship between the actor and the theatrical environment, between the spectator and the theatrical environment, between the actor and the spectator, and among the spectators themselves. Of course he has not done this in any one play, but his willingness to experiment has been part of his theater almost from its inception.

In many cases, Arrabal has tried to return to the origins of the theater in his search for new patterns. These patterns, uncommon in our traditional theater in which sequential logic and organic development of plot and character have been touchstones, rely more on a subjective and aesthetic logic than on a linear dramatic organization. The result is a theater in which randomness, disorder, and anarchy reign supreme, in which baroque excess and the grotesque frequently constitute the salient characteristics.

Given the fact that Arrabal tries to create a scenic metaphor and relies less on language than the playwrights of the traditional theater, he can be placed among the absurdists of the post World War II period. Yet there are distinguishing characteristics in his theater that cannot be overlooked. Arrabal's characters to a man remain true to a type of psychic innocence even in face of their obvious guilt, which is, of course, imposed upon them by the morality of a society that lies beyond their comprehension. Instead of the world-weary, worldwise, and jaded characters of the absurdists, one encounters either adult children living in a world of their own devising or juveniles about to be initiated into the fantasy world of love and panic. Even the prisoners of *and they put handcuffs on the flowers,* despite dozens of years in the hell hole of a prison, do not lose a certain innocence, a sense of the marvelous, a childlike wonder. Too, the characters of the *Théâtre bouffe* go on their zany way, ignoring the perils of the technological world they live in. This attitude of Arrabal's characters in face of a grim world of reality, in conjunction with the emphatically grotesque and erotic elements and the ritualistic structure, give him at least a special niche in the pantheon of the absurdists, if not a theatrical chapel all his own.

Although Arrabal has lived in Paris for more than twenty years and has a following that is international, it would be an error to entirely discount the influences of his Spanish background on his

theater. The Spanish government even in the post-Franco period continued to place him among the most troublesome of political enemies until 1977. Even now he refuses to return to Spain until all political prisoners have been released. Arrabal has not forgotten that he is Spanish, despite his international fame, although he does admit to speaking a Spanish that is less than contemporary.[4] The political situation in Spain under Franco plays an obvious and important role in at least three plays: *The Two Executioners,* in which Françoise betrays her husband to the Fascist authorities; *Guernica,* which depicts an elderly couple, Fachou and Lira, immediately after the firebombing of that Basque village; and finally, *and they put handcuffs on the flowers,* set in a Spanish prison. The Spanish state, one of the principal preoccupations of most Spaniards, according to George Wellwarth,[5] shows its totalitarian head most explicitly in these plays. But like most of his fellow Spanish writers, Arrabal has a strong taste for allegory behind which he may hide a critique of the Spanish regime. Thus, it could be argued that the figure of the police in such plays as *The Tricycle* and *Ceremony for a Murdered Black* also represents the oppression of the police state in Spain. Similarly, *The Labyrinth,* in which a godlike figure named Justin turns out to be a tyrant in his universe of blankets and bedclothes, could be meant to represent a tyrant of Franco's ilk. Arrabal, like many modern playwrights, writes of his personal universe, but he does not ignore the lack of freedom imposed by the governmental system in his homeland. His password is freedom, and he denounces all tyrannies, both political and spiritual.

In more recent years, his attacks on the tyranny of the state, church, or any other authority have become more insistent. *Heaven and Crap* and *The Twentieth Century Revue* leave no doubt as to the target of Arrabal's barbs, be they in Spain or elsewhere. Hitler, Truman, and Our Lady of Fatima are openly caricaturized in these grotesque comic strips for the theater. Moreover, post-Franco Spain, as it enters into the capitalistic mainstream and perforce leaves some of the old Spanish traditions behind, receives a panicky warning from Arrabal in *The Tower of Babel.* Nowhere is Arrabal more touching in his expression of feelings toward his mother country than in *On the High Wire,* where the Duke, Tharsis,

and Wichita represent the Arrabal caught between the freedom necessary for his art that he has found in Paris and the desire to see Spain revere its artists and respect their freedom.

Dependent as he is on his memories for inspiration, Arrabal cannot sublimate his Catholic education in a country that remains the stepchild of the Inquisition. A cursory view of his plays easily uncovers the Christ figures: Emanou in *Automobile Graveyard,* Tosan in *and they put handcuffs on the flowers,* and Chester in *Today's Young Barbarians.* The simplistic carrot-and-stick morality of Arrabal's adult children; the pervasive ideas of guilt, innocence, and pardon; and the harsh and unjust superiors show Arrabal's debt to his early education in the strict tradition of Spanish Catholicism. The macabre but comic action of *First Holy Communion* underscores Arrabal's fascination with the grotesque distortion of Catholic beliefs. In *The Garden of Earthly Delights,* we see a portrait of Catholic convent schools as prisons, or mother superiors as wicked wardens, and of students as oppressed victims of a system that provides no mercy for young individualists. *The Architect and the Emperor of Assyria* contains some typically scurrilous attacks on the concept of confession, as we see a Carmelite nun seduced by her confessor. And the ritual of the last scene is an obvious reference to the rite of the sacrifice of the mass and holy communion. *And they put handcuffs on the flowers* portrays the church in collusion with the state, priests as toadies to be castrated, visions of Our Lady of Fatima as distortions of erotic and scatological dreams.

Although repressed sexuality is by no means a uniquely Spanish phenomenon, the resultant display of a bloody, baroque violence seems to be very Spanish. Here again the puritanical views of the Spanish church come into direct conflict with the openly erotic aspects of the Spanish character. Bataille's thesis that eroticism is generated only by the dialectic of interdict and transgression could not find a more pertinent proof than in the Iberian Peninsula. Neither can one find a more insistent example in the contemporary avant-garde theater than in the sadomasochistic games of Cavanosa in *The Grand Ceremonial* or in the ever-increasing violence of *The Condemned Man's Bicycle.* Where in the theater is love pictured as a wild but tender gorilla as it is in *The Garden of Earthly Delights?* Such florid images are not to be found elsewhere in the theater

today, nor shall we find a playwright of major international stature who brings so much of his ethnic character to bear on his works as does Arrabal.

Much of the originality of Arrabal's theater derives from his rich repertory of images, fantasies, and illusions. His theater is indeed a personal insight on the verities of the human condition. Yet it is at this point that conflict arises, for if Arrabal is to be successful he must translate the personal, even intimate vision into terms that can be understood by the general public. It is clear that he frequently succeeds in this task; it is equally clear that he sometimes fails. In comparison with a Beckett or an Ionesco, his works appear unkempt and untidy—far from the jewel-like precision that those two masters display in their craft. But Arrabal's more elaborate vision requires more attention to the details that will permit his genius to show. The spontaneity of his metaphors must not be sacrificed to technique and to a studied posture, as frequently happens in the Panic Theater, but must be preserved and nurtured in a careful elaboration of his vision. When he is successful in finding the appropriate theatrical framework, Arrabal touches our deepest emotions, he brings life to the liveliest of the arts, and he teaches us what it means to be human. Arrabal's theater is a unique adventure.

## Notes

1. James Roose-Evans, *Experimental Theatre* (New York: Avon Books, 1970), p. 96.
2. Odette Aslan, "Le Cimetière des voitures, un spectacle de Victor Garćia à partir de quatre pièces d'Arrabal," in *Les Voies de la Création théâtrale I*, ed. Jean Jacquot (Paris: Editions du Centre National de la Recherche Scientifique, 1970), pp. 311-39.
3. Gabriel Marcel, "Une technique d'avilissement," *Les Nouvelles littéraires,* December 28, 1967, p. 13. Translation is mine.
4. Richard Eder, "For Arrabal Spain Is Still in the 1950's," *New York Times,* May 26, 1976, p. 24.
5. George E. Wellwarth, *The Theatre of Protest and Paradox* (New York: New York University Press, 1971), p. 354.

# Bibliography

Alexander, Caroline. "Arrabal plaide au palace." *L'Express,* March 6-12, 1972, p. 53.

Amary, Camille. "Le Jardin des délices." In Fernando Arrabal, *Théâtre 4,* pp. 9-12. Paris: Christian Bourgois, 1969.

Arrabal, Fernando. *Baal Babylone.* Paris: Union générale d'Editions, 1971.

———. "El Hombre Pánico." In *Primer acto,* pp. 27-37. Madrid: Ediciónes Taurus. 1965.

———. *Jeunes barbares d'aujourd'hui.* Paris: Christian Bourgois, 1975.

———. "Les Prisons espagnoles." *Le Monde,* October 31, 1967, p. 13.

———. *Sur le fil ou ballade du train fantôme,* Paris: Christian Bourgois, 1974.

———. "Textes paniques." *La Brèche* 1 (September 1962): 9-12.

———. *Théâtre 1.* Paris: Christian Bourgois, 1968. (Contains *Oraison, Les Deux bourreaux, Fando et Lis, Le Cimetière des voitures.*)

———. *Théâtre 2.* Paris: Christian Bourgois, 1968. (Contains *Guernica, Le Labyrinthe, Le Tricycle, Pique-nique en campagne, La Bicyclette du condamné.*)

———. *Théâtre 3.* Paris: Christian Bourgois, 1969. (Contains *Le Grand cérémonial, Cérémonie pour un noir assassiné.*)

———. *Théâtre 4.* Paris: Christian Bourgois, 1969. (Contains *Le Lai de Barabbas, Concert dans un oeuf.*)

———. *Théâtre 5.* Paris: Christian Bourgois, 1967. (Contains *Théâtre Panique, L'Architecte et l'Empereur d'Assyrie.*)

————. *Théâtre 6*. Paris: Christian Bourgois, 1969. (Contains *Le Jardin des délices, Bestialité érotique, Une Tortue nommé Dostoievsky.*)

————. *Théâtre 7, Théâtre de guerilla*. Paris: Christian Bourgois, 1969. (Contains *Et ils passèrent des menottes aux fleurs, L'Aurore rouge et noire.*)

————. *Théâtre 8*. Paris: Christian Bourgois, 1970. (Contains *Ars Amandi, Dieu tenté par les mathématiques.*)

————. *Théâtre 9*. Paris: Christian Bourgois, 1972. (Contains *Le Ciel et la merde, La Grande revue du XXe siècle.*)

————. *Théâtre 10*. Paris: Christian Bourgois, 1972. (Contains *Bella Ciao ou La Guerre de Mille Ans.*)

————. *Théâtre 11*. Paris: Christian Bourgois, 1976. (Contains *La Tour de Babel, La Marche royale, Une orange sur le Mont de Vénus, La Gloire en images.*)

————. *Théâtre 12. Théâtre bouffe*. Paris: Christian Bourgois, 1978. (Contains *Volemoi un petit milliard, Le Pastaga des loufs ou ouverture orang-outan, Punk et Punk et Colégram.*)

Artaud, Antonin. *The Theatre and Its Double*. Translated by Mary C. Richards. New York: Grove Press, 1958.

Aslan, Odette. "Le Cimetière des Voitures, un spectacle de Victor Garćia à partir de quatre pièces d'Arrabal." In *Les Voies de la Création théâtrale I*, pp. 311-39. Edited by Jean Jacquot. Paris: Editions du Centre National de la Recherche Scientifique, 1970.

Bastide, François-Regis. "Un art consommé qui se consume vite." *Les Nouvelles littéraires*, March 13-19, 1972, p. 24.

Bataille, Georges. *L'Erotisme*. Paris: Union générale d'Editions, 1957.

Biner, Pierre. *The Living Theatre*. New York: Horizon Press, 1972.

Caillois, Roger. *Les Jeux et les hommes*. Paris: Editions Gallimard, 1958.

Coe, Richard. "Les Anarchistes de droite." *Cahiers Renaud-Barrault* 67 (September 1968): 99-125.

Cohn, Ruby. *Currents in Contemporary Drama*. Bloomington: Indiana University Press, 1969.

Copleston, Frederick, S.J. *A History of Philosophy*. vol. 1, part 1. Garden City, N.Y.: Image Books, 1956.

Croyden, Margaret. "Here Nothing Is Forbidden." *New York Times*, Sunday, August 9, 1971, sec. 2, pp. 1 and 3.

Davis, R.G. "Guerrilla Theatre." *The Drama Review*, 32 (Summer 1966): 130-35.

De Long-Tonelli, Beverly J. "Arrabal's Dramatic Structure." *Modern Drama* 16 (September 1971): 205-9.

Eder, Richard. "For Arrabal Spain Is Still in the 1950's." *New York Times*, May 26, 1976, p. 24.

Eliade, Mircea. *The Myth of the Eternal Return*. Translated by Willard R. Trask. New York: Pantheon Books, 1954.

————. *The Sacred and the Profane*. Translated by Willard R. Trask. New York: Harcourt, Brace and World, 1959.

Espinasse, Françoise. "Entretien avec Arrabal." In Fernando Arrabal, *Théâtre 3*, pp. 7-22. Paris: Christian Bourgois, 1969.

Esslin, Martin. *The Theatre of the Absurd.* Garden City: Anchor Books, 1961.

Fergusson, Francis. *The Idea of a Theatre.* Princeton: Princeton University Press, 1949.

Gille, Bernard. *Fernando Arrabal.* Paris: Seghers, 1970.

Gouhier, Henri. "Théâtre populaire: le cas d'Arrabal." *La Table ronde* 232 (May 1967): 122-28.

Guicharnaud, Jacques. "Forbidden Games: Arrabal." *Yale French Studies* 29 (1962): 116-20.

————. *Modern French Theatre.* New Haven: Yale University Press, 1961.

Hegel, Georg W. F. *The Phenomenology of Mind.* Translated by J. B. Baillie. New York: Harper and Row, 1967.

Huizinga, John. *Homo Ludens.* Boston: Beacon Press, 1955.

Ionesco, Eugène. "Une Cure de désintoxication." *Le Figaro,* May 13-14, 1978, p. 27.

Kanter, Robert. "L'Ivresse râpeuse d'Arrabal." *L'Express,* March 22-27, 1967, pp. 57-58.

Kerr, Walter. "Doesn't This Playwright Want Us to Care?" *New York Times,* Sunday, April 30, 1972, sec. 2, p. 30.

Marcel, Gabriel. "Une technique d'avilissement." *Les Nouvelles littéraires,* December 28, 1967, p. 13.

Piaget, Jean. *Language and Thought of the Child.* Translated by Marjorie Warden. New York: Meridian Press, 1955.

Poirot-Delpech, Bertrand. "Bella Ciao, d'Arrabal et Lavelli," *Le Monde,* March 4, 1971, p. 21.

Raymond-Mundschau, Françoise. *Arrabal.* Paris: Editions universitaires, 1972.

Roose-Evans, James. *Experimental Theatre.* New York: Avon Books, 1970.

Schechner, Richard. "Approaches to Theory/Criticism." *The Drama Review* 10 (1966): 20-53.

Schifres, Alain. "Arrabal: le théâtre panique." *Réalités* 252 (January 1967): 54-57.

————. *Entretiens avec Arrabal.* Paris: Pierre Belfond, 1969.

Serreau, Geneviève. "Un nouveau style comique, Arrabal." *Les Lettres nouvelles,* (November 1958): 573-82. also appears as "A New Comic Style." *Evergreen Review* 4 (November-December 1960): 61-69.

Shattuck, Roger. *The Banquet Years.* New York: Vintage Books, 1955.

Watts, Richard. " 'And They Put Handcuffs' at the Mercer O'Casey," *New York Post,* April 22, 1972, p. 19.

Wellwarth, George E. *The Theatre of Protest and Paradox.* New York: New York University Press, 1971.

### Editions of Arrabal's Plays in English

*Plays.* Vol. 1. London: Calder and Boyars, 1962. (Contains *Orison, The Two Executioners, Fando and Lis, The Car Cemetery.*)

*Plays.* Vol. 2. London: Calder and Boyars, 1967. (Contains *Guernica, The Labyrinth, The Tricycle, Picnic on the Battlefield, The Condemned Man's Bicycle.*)

*Plays.* Vol. 3. London: Calder and Boyars, 1970. (Contains *The Architect and the Emperor of Assyria, The Grand Ceremonial, The Solemn Communion.*)

*And they put handcuffs on the flowers.* Translated by Charles Morowitz. New York: Grove Press, 1973.

*The Architect and the Emperor of Assyria.* Translated by Everard d'Harnoncourt and Adele Shank. New York: Grove Press, 1969.

*First Holy Communion.* In *Modern Spanish Theatre,* edited by Michael Benedikt and George Wellwarch, pp. 309-17. New York: E. P. Button, 1969.

*Garden of Delights.* Translated by Helen and Tom Bishop. New York: Grove Press, 1974.

*Groupuscule of My Heart,* translated by Bettina Knapp. In *The Drama Review,* no. 4 (Summer 1969): 123-28.

*Guernica and Other Plays.* Translated by Barbara Wright. New York: Grove Press, 1969.

*Picnic on the Battlefield,* translated by James Hewitt. In *Evergreen Review* 4, no. 15 (November-December 1960): 76-90.

*Solemn Communion, Striptease of Jealousy, Impossible Loves,* translated by Bettina Knapp. In *The Drama Review,* no. 13 (Fall 1968): 71-86.

# Index

151

## General

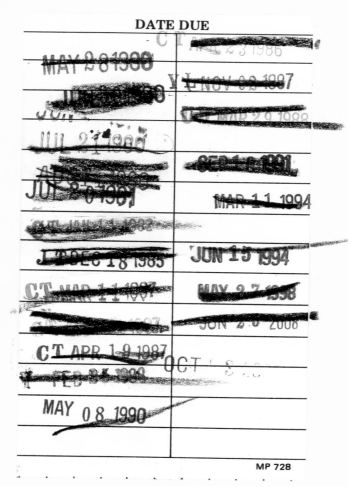

**DATE DUE**